BLACK AMERICA SERIES

AFRICAN AMERICANS
OF EASTERN LONG ISLAND

BLACK AMERICA SERIES

AFRICAN AMERICANS
OF EASTERN LONG ISLAND

Jerry Komia Domatob, Ph.D.

ARCADIA

First printed in 2001.

Published by Arcadia Publishing,
an imprint of Tempus Publishing, Inc.
2A Cumberland Street
Charleston, SC 29401

Printed in Great Britain.

Library of Congress Catalog Card Number: 2001088819

For all general information contact Arcadia Publishing at:
Telephone 843-853-2070
Fax 843-853-0044
E-Mail sales@arcadiapublishing.com

For customer service and orders:
Toll-Free 1-888-313-2665

Visit us on the internet at http://www.arcadiapublishing.com

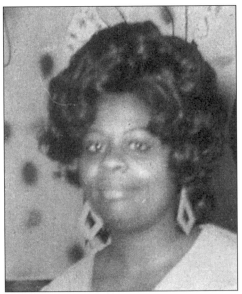

Two people who contributed much to this work are from the African American Museum in Hempstead. They are historian and curator Mildred Clayton, who has lived on Long Island for more than four decades, and and Willie Houston, museum director, who is known throughout Long Island for promoting African American history and culture.

CONTENTS

ACKNOWLEDGMENTS

This project needed encouragement and support. Fortunately, a number of people provided that boost, and I immensely appreciate it. Some friends gave me photographs; others offered kind words and suggestions. That was motivating, and I thank everyone.

Projects such as this one require patience, perseverance, and an unquenchable interest in the research. They test our mettle and remind us of how much we owe to our parents and family. It was my late father—one of Cameroon's pioneer teachers, headmasters, and administrators—who imbued in his children the sense of hard work, determination, and diligence. Pah Vincent Phillip Domatob was a great and outstanding father. Through noble words and actions, he encouraged us to study, to respect people and customs and laws, and above all to strive toward bequeathing legacies to posterity. This book reflects his training, example, and counsel.

Mama Domatob has never relented in her motherly duties. She has always provided sound advice and help. It is a blessing to have parents who cared for us with profuse and profound love. We can never repay them for all the services they rendered. I also salute my sisters, who have kept to the worthy tradition our parents championed. All of them—Mah Odi, Mah Rose, Mah Mary, Mah Ann, Kah Bridget Sahmi, and Dr. Frida Nahvet Domatob—are leading women with vision and a sense of mission. My nephews and nieces follow the same path, and we are all proud of them.

Finally, Arcadia Publishing motivated me to forge ahead. The company's interest in publishing the book buoyed my spirits. My editor Pam O'Neil was a great coach, and it was a delight working with her.

The photographs and history came from many sources: Dr. Brisbane, Provost Tim Bishop, Dr. Marc Fasanella, Jane Finalbargo, Carrie Gilbert, Mr. and Mrs. Richardson, Audrey Gaines, Lucius Ware, Judith Mitchell, Reverend Liggon, Rev. Charles Earle Hopson, Rev. Marvin Dozier, Elsie Owens, Pastor and Mrs. McElroy, Dr. Lolita Mitchner, Ardell and Curtis Highsmith, Rev. Sharlene Hartwell, Henry Letcher, Andy Malone, Larry Toler, Joan Carpenter, Yolanda Jackson, Mary Langhorn, Gwen Branch, Cynthia Turner, Derrick Robinson, Victoria Gumps, A. Steven Moore, Cathy Tucker, Joanne and Bob Carter, David Carney, Janice Tinsley-Colbert, Rev. Henry Faison, Cynthia Turner, Mary Diamond, Majorie Hayes, Rae Parks, Nancy Stevens, Michael Mackey, Helen Hamilton, Hazel Sharon Sanders, Rennae Flack, Judge Maryette Cooper-Upshur, Bill Brazier, Robert Cox, Bridgehampton Historical Society, Eastville Community Historical Society, Sag Harbor, Pat Gholson, Rani Carson, Elick and Willie-Mae Pinckney, Stony Brook Museums, Leon Parks, Ruth Watkins, Rev. Cornelius Fulford, Bessie Ford and the Turners. I am grateful to all of these benefactors. To any whose names are missing: please forgive me; the omission is not intentional.

Special thanks goes to Robert Wilson, Rev. Charles Alfred Coverdale, Willie Houston, Mildred Clayton, Mary Trafton, Carole Booker-Joynes, Delano Stewart, Gary Cooley, Brenda Simmons, Rosa Hanna, Denise Cooper, Lucius Ware, Claudia Smith, Southampton Historical Museum, Joanne Carter, Long Island Studies Institute at Hofstra University, and African American Historical Museum, Hempstead. These friends went above and beyond my expectations. Their kindness and generosity is preciously cherished.

PREFACE

The African American population of Long Island's East End is now and has been for centuries a vital force in the life of the community. Its history is inextricably entwined with the Native American tradition of the region, with the history of the land's colonization, with its agricultural past, with its development as a resort community, and with its present growth and future hopes.

It is remarkable that the story of the East End's African Americans has been so long neglected, and it is fortunate that a work such as Jerry Domatob's is appearing to fill the vacuum that has deprived readers of access to what this book will show is a vibrant and pivotal segment of the island's society. *African Americans of Eastern Long Island* makes an invaluable introduction to this fascinating subject.

—Robert Pattison
Professor of English, Southampton College of Long Island University

INTRODUCTION

Long Island is fast evolving into a multicultural community of residents from all backgrounds. People of African, European, Latino, and Asian descent live on the island, reputed for its gorgeous landscapes and celebrity-packed communities. However, one group that has made significant although unsung contributions to the island is the African American population.

This is one of the first books that highlights the African American role on the island. Based on specific success stories, the book provides a wide array of personalities and people who helped shape the history of eastern Long Island communities.

Focusing on the island's earliest African Americans, the book tells this important story in rare pictures and narrative. Among the personalities who have bequeathed a lasting legacy are pastors and jurists, educators and athletes, musicians and business executives, activists and political leaders.

Jerry Komia Domatob, an international scholar, has written books and articles on African and African American issues. A prolific author, he holds two master's degrees, in international relations and journalism, from Carleton University, Ottawa, Canada. He received his doctorate in mass communications from Ohio University, Athens. He taught at the University of Northern Iowa before proceeding to Long Island University, where he currently teaches communication, African literature, and African American literature. He was a pioneer lecturer and department head at the Department of Mass Communications, University of Maiduguri-Nigeria, West Africa.

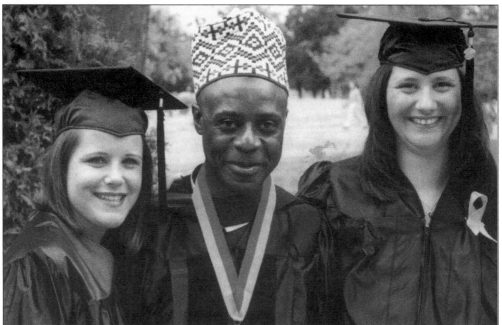

At Long Island University's graduation ceremony, author Jerry Komia Domatob stands outside with Southampton College communication students Julie Klebonis (left) and Jennifer Geffe. (Author's collection.)

One
BRIDGEHAMPTON
WORK AND SERVICE

Bridgehampton is one of the areas where African Americans settled during the 20th century. Most of them came initially as migrant workers from North Carolina, South Carolina, and Virginia. Unlike Sag Harbor, which attracted educated and professional people, Bridgehampton emerged as a home for working-class African Americans.

By the 1920s, some permanently settled in Bridgehampton, where they worked on farms and private homes. Pioneer African American families in Bridgehampton included the Browns, Marshalls, Charltons, Hopsons, Joneses, Mayers, McKays, Thomsons, and Pinckneys. The increase in their population partly led to the birth of Bridgehampton First Baptist Church, in the early 1920s.

As more people came to Bridgehampton, a tragedy that shocked the community struck. In 1952, 11 children and 3 adults who were squatting in a 12-by-20-foot shed fell victim to disaster. The shed—an abandoned chicken house with neither an exit door nor a partition—was hidden in the woods, removed from the handsome houses of the masters. Inside, a lamp fell and sparked a fire, and two of the little children burned to death. This catastrophe precipitated the move to create the Bridgehampton Child Care Center. Located on the Sag Harbor Turnpike, that center organizes after-school events for children and youth and is one of the leading community centers on the East End.

Bridgehampton has an interesting history that dates back to 1656, when Southampton resident Josiah Stanborough built a house in Sagaponack. The bridge linking Sagg and Mecox led to the birth of Bridge Street and later Bridgehampton, which literally and metaphorically links East Hampton and Southampton, reputed for attracting affluent people, vacationers, and celebrities.

Several families settled in the area c. 1730, due to the booming whaling industry, the most profitable business at the time. In 1775 and 1776, during the Revolution, a volunteer militia prevented the British fleet from invading the region. Since the 1800s, Bridgehampton, like the rest of the Hamptons, has served as an attractive summer resort. Pres. Woodrow Wilson was one of the famous people who spent his 1898 vacation in the area. The film legend Mary Pickford shot the movie *Huldah Holland* in Bridgehampton, using the scenery in the town as the Dutch village. TV anchor Peter Jennings has a home there. At the beginning of the 21st century, Bridgehampton had several thousand residents.

Although the majority of African Americans came to the area as farmhands, those in Bridgehampton today own homes and work in various professions, mostly along the Sag Harbor Turnpike. They include technicians, landscapers, nurses, teachers, and construction workers. African American students attend Bridgehampton High School, located on Sunrise Highway, which excels in basketball.

As property values skyrocket and youths leave in search of better job prospects, what is the future of the African American population in Bridgehampton? The following pages may not hold the answer, but the past that is captured in the pictures and stories can offer a source of inspiration for the days ahead.

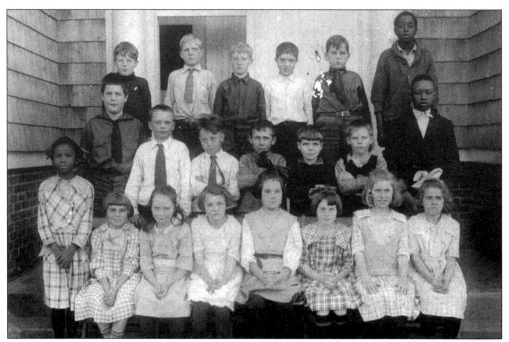

During the 1923–1924 school year, Virginia Williamson (front row, far left) and Winton Williamson (middle row, far right) are pictured at the Bridgehampton grade school. At the time, grade school and middle school classes were held in the same building. (Courtesy of Bridgehampton Historical Society.)

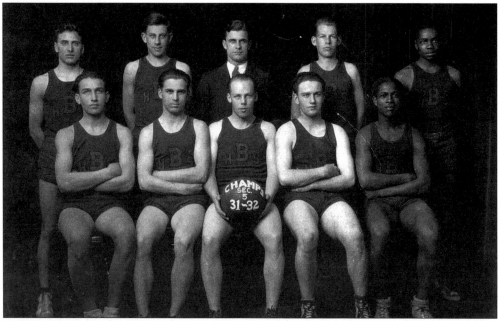

Bridgehampton High School is reputed for excellence in basketball. The school's gymnasium is adorned with souvenirs of victories won over the years. Vincent Grubb (front right) and George Williamson (back right) were part of the team that won the championship in 1932. (Courtesy of Bridgehampton Historical Society.)

These early scenes show an African American trooper working in the Montauks. (Courtesy of Bridgehampton Historical Society.)

This photograph shows the Class of 1932 graduates of Bridgehampton School. In the back row are Evelyn Williamson and M. Stewart. (Courtesy of Bridgehampton Historical Society.)

Irving Bill Marshall (1893–1985) was one of the first African Americans to graduate from Bridgehampton schools. A man with West Indian roots, he carved a niche for himself in the community as a musician, an athlete, and a gardener. A respected citizen and staunch member of the Presbyterian church in Bridgehampton, Marshall had a subtle and outstanding way of negotiating matters of race, ethnicity, and class. (Courtesy of Bridgehampton Historical Society.)

Alice (Ford) Darden, who was born in 1911, married
Harrison Darden. The Dardens lived and worked in
Bridgehampton, where they raised three children.
(Courtesy of Bessie Thomas.)

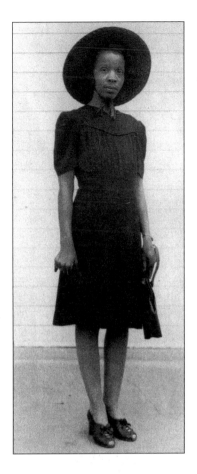

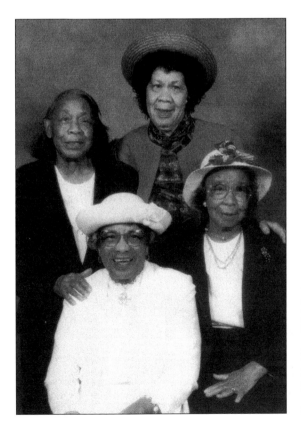

The Ford sisters, respected mothers in
Bridgehampton, have spent significant
portions of their life in the Hamptons.
They have been in Bridgehampton
since the 1927. Seated are 90-year-old
Bessie Ford Thomas (left) and Alice
Ford Darden. Standing are Jenny
Wyche and Annie Wyche. (Courtesy
of Bessie Thomas.)

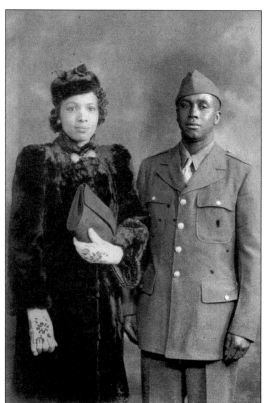

Pictured in Bridgehampton are Robert and Bessie (Ford) Thomas, who were married in the 1930s. He was born in 1907 and she in 1910. He fought in World War II, after which he worked with the United Transport Service in New York City for over three decades. After he retired in 1974, the couple returned to Bridgehampton. (Courtesy of Bessie Thomas.)

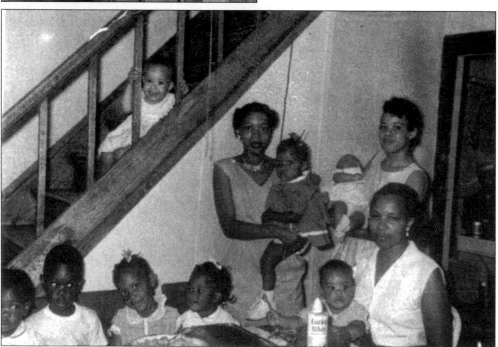

Bessie Thomas sits with her nieces at a family picnic that she organized in 1958. Family members Gloria Gilliam and Geraldine Johnson are standing with the children.

This is the Thomas house in Bridgehampton. Built in 1924, the house is still solid. Standing out front is Bessie Thomas. (Courtesy of Bessie Thomas.)

Seated, from left to right, are Melanie Wyche, Mary Wyche, Willie Ford, Otis Wyche, and Jenny Wyche and her granddaughter Connie Wyche. Standing behind them is the brother of Mary Wyche. The picture was taken in the 1960s. (Courtesy of Bessie Head.)

This graduation picture shows the Bridgehampton High School Class of 1954. Seated on the far right is Barbara Person, the pianist of First Baptist Church of Bridgehampton. (Courtesy of Bessie Thomas.)

Bridgehampton High School was founded in the 1930s. Fred Coverdale—one of Long Island's first African American high school principals—earned his bachelor's degrees and two master's degrees from Delaware State University and State University of New York at Stony Brook in history and sociology in 1960, 1972, 1974, and 1976, respectively. He also served at Bayport High School. (Courtesy of Fred Coverdale.)

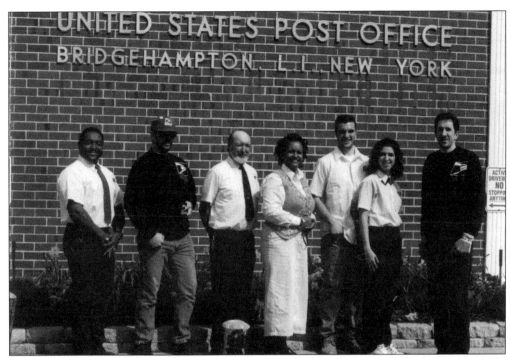

Shown here with her staff is JoAnn Armstrong (center), one of the first African-American women to serve as postmaster on the East End. (Author's collection.)

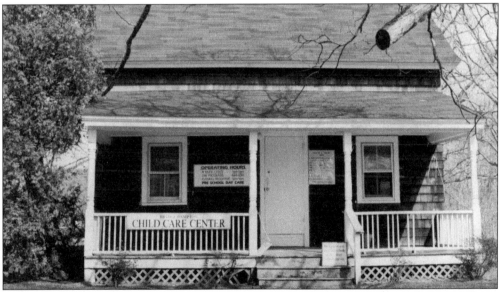

Bridgehampton Child Care Center on Northville Turnpike was established in 1952. It came into being in the wake of a fire that took the lives of two children of African American migrant workers. The family was among more than a dozen people living in a small chicken house, where an oil lamp sparked the tragic fire. Members of the community were appalled by the incident, and Dorothy Brush donated the building and land on which Bridgehampton Child Care and Recreation Center was established and still operates to this day. (Courtesy of Bridgehampton Child Care Center.)

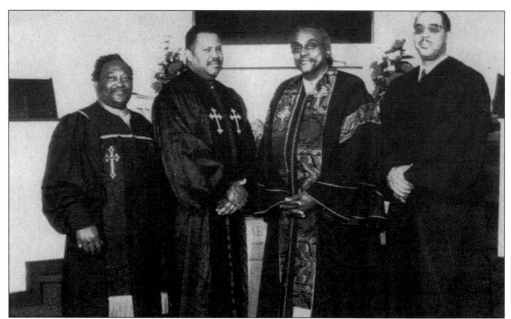

Rev. Henry Faison (second from right) has led First Baptist Church of Bridgehampton for almost three decades. Under his leadership, the church has consolidated its growth and the choir has grown and become highly admired on the East End. With him are, from left to right, Revs. Maylon Lamison, Carlyle Turner, and Michael Jackson. (Courtesy of Reverend Faison and First Baptist Church of Bridgehampton.)

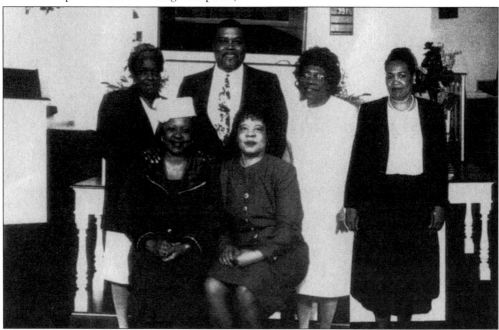

These officers of the First Baptist Church of Bridgehampton have local roots dating back to the early settlers. The are, from left to right, Naomi Davis, Theressa King, John Bowe, Gloria Gilliam, Lillie Robinson, and Gloria Harris. (Courtesy of Reverend Faison and First Baptist Church of Bridgehampton.)

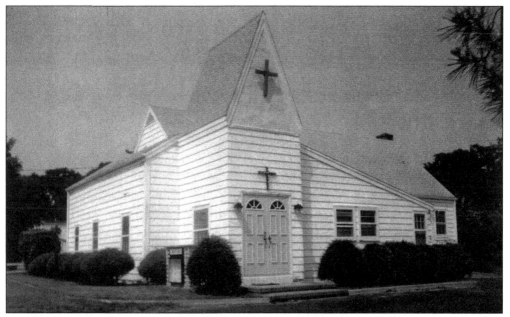

First Baptist Church of Bridgehampton was formed in 1925. The building was constructed in 1979-1980 and was dedicated in 1980. Rev. Chester Johnson, a builder, supervised the construction. An imposing structure, the church serves as a religious and social center. Reputed for excellent music and lively singing, it attracts members from all parts of the island. (Courtesy of Reverend Faison and First Baptist Church of Bridgehampton.)

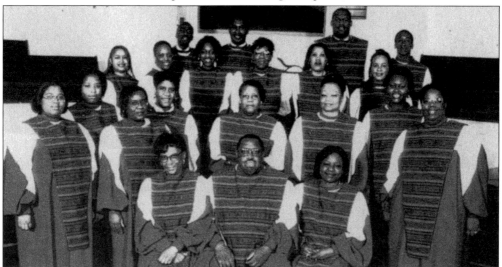

Bridgehampton Choir and Faison Ensemble draw prominent Long Islanders who trace their history back the 1920s and 1930s. Shown are, from left to right, the following: (first row) Barbara Person, Curtiss Moore, and Therresa King; (second row) Erika Gaud, Darlene Mackey, Penny Walker, Benita Lattimore, Esther Pinckney, Flora Gilliam, Tanya Dawson, and Daisy Bowe; (third row) Connie Gaud, Sheila Benton, Josephine Nelson, Helen Giles-Smith, Dorothy Jackson, and Joanne Brown; (fourth row) Kenneth Brown, Jerome Walker, Damon Darden, and DeuBoyce Robinson. (Courtesy of Reverend Faison and First Baptist Church of Bridgehampton.)

These prominent East End women are members of Bridgehampton Church of God in Christ. They include Thelma Malone, Carolina Stevens, Florence Turner, and Martha Cragette. (Author's collection.)

Bridgehampton Church of God in Christ has been in existence for about half a century. Gathered outside are church members of all ages. (Author's collection.)

Ellick and Willie Mae Pinckney married in 1952. He was born in Walterboro, South Carolina, and migrated to Long Island in 1942. He worked as a potato farmer, a contractor, and a carpenter. She was born in Elizabeth City, North Carolina, and came to Bridgehampton in the 1940s to harvest potatoes as a migrant worker. After graduation from high school, she relocated to Bridgehampton in 1951, where she did domestic and farm work. The Pinckneys opened and managed a successful bar in the 1950s. They also bought land on the Sag Harbor Turnpike in the 1960s and built rental homes. Pinckney retired in 1989. (Courtesy of Willie Mae Pinckney.)

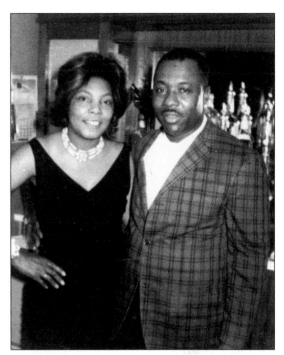

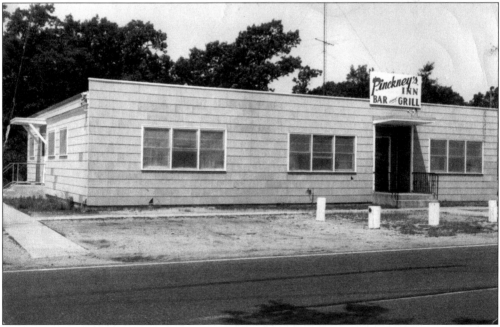

Pinckney's Inn, a bar and grill now called Bridges, was one of the leading social and entertainment centers for East End African Americans for almost four decades. Located on Bridgehampton's Sag Harbor Turnpike, it attracted celebrated musicians during its heyday. Otis Redding, Joe Tex, Willie "Fatman" Brinson, Wilson Picket, and Billy Bland all performed there. It was the only African American bar in Bridgehampton with a pink interior and exterior. Similarly, the upholstery and dishes were pink. It became a local institution where people came to eat, drink, dance, and party. (Courtesy of Willie Mae Pinckney.)

In 1948, Patricia Gholson was five years old (left). She appears in later years in her Eastern Star uniform. She was one of the first African Americans to be employed at Southampton College, in 1965, two years after the college was established. She has served the college with distinction for nearly four decades, most recently as assistant registrar. She holds two bachelor's and a master's degree from Long Island University. An accomplished pianist, she has played at many East End Churches and is currently a pianist for Unity Baptist Church in Mattituck. (Courtesy of Patricia Gholson.)

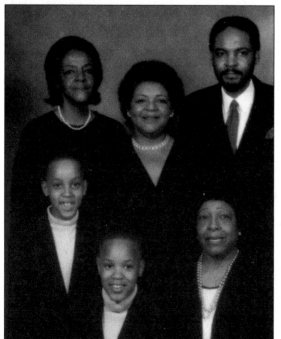

The Gholsons are a respected family on the East End. Over the last century, they made worthwhile contributions to the church and community. Pictured, from left to right, are: (front row) James Gholson, Edward Gholson, and Beatrice Gholson; (back row) Elaine Parks, Patricia Gholson, and Kenneth Gholson. Beatrice Gholson, mother of Patricia, came to Bridgehampton from the South. (Courtesy of Patricia Gholson.)

Lynda Joyce Jones was born and raised in Bridgehampton. Her family moved to the area in the 1940s. She graduated from Bridgehampton High School and attended the Fashion Institute of New York. She is the co-owner of Belle's Cafe in Westhampton. (Courtesy of Lynda Joyce Jones.)

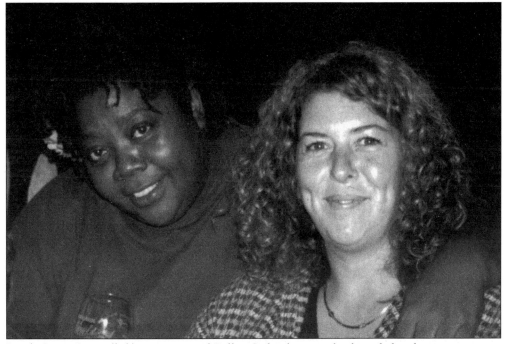

Lynda Joyce Jones (left), co-owner of Belles Café, shares a drink with her business partner, Jennifer Rand (right). The popular East End café serves a blend of African American and European cuisine and attracts a multicultural crowd. (Courtesy of Lynda Joyce Jones.)

23

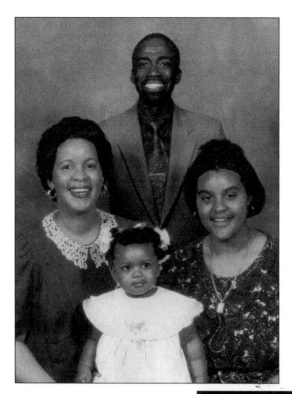

Pictured, from left to right, are Joanne Wyche Brown, Kenneth Brown, Adrienne Warren, and Alaya Brown. The Browns currently reside in Bridgehampton. They are prominent in church and community activities. (Courtesy of the Browns.)

The Hopson family is well-known in Bridgehampton. Arthur Phillip Hopson Sr. was born in 1924 and died in 1990. A farmer and outstanding parent, he is the father of the current pastor of Calvary Baptist Church, Charles Hopson Jr. of East Hampton. (Courtesy of Charles Hopson.)

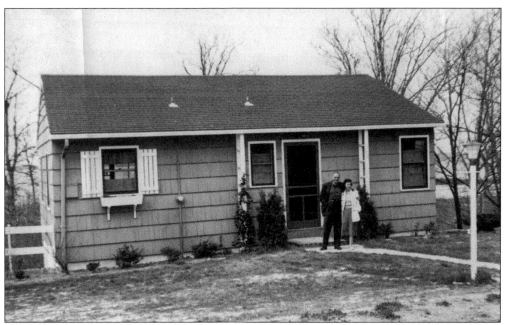

This African American home, located on the Bridgehampton Turnpike, has a simple design. However, then as now, it was a source of accomplishment and pride for a family to own a house.

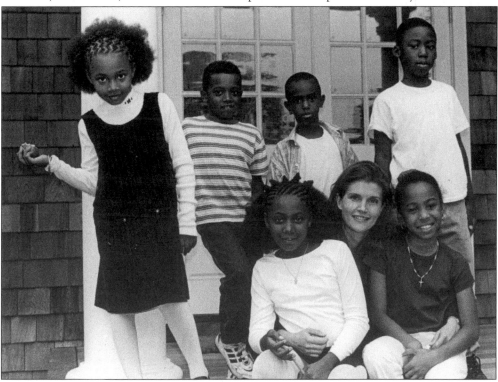

Children and the manager of the Bridgehampton Child Care Center celebrate a special event. Since the creation of the center in 1952, African American children from Bridgehampton have had their own place to meet, play, sing, dance, and learn.

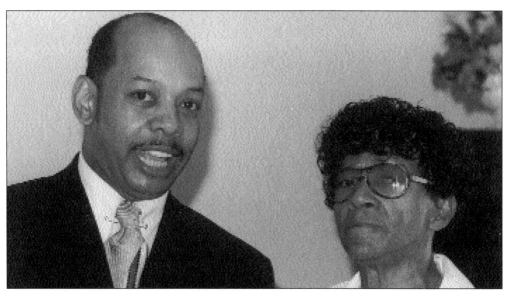

John Wyche (left) is the advertising manager of Southampton Press and a community leader. Cecelia Robinson (right) is a longtime resident of the East End who worked in the laundry industry. (Author's collection.)

In the early 1900s, before urbanization became the trend, Bridgehampton was characterized by a beautiful landscape, lush with luxuriant vegetation. Today, it is fast developing a metropolitan atmosphere. (Courtesy of Bridgehampton Child Care Center.)

Two
EAST HAMPTON
FAMILY AND FAITH

Even though East Hampton is a beehive, bustling with activities in the summer like most of Long Island, its tranquil charm is proverbial. The lovely forests and rich vegetation graced with spacious homes make it a remarkable holiday resort. African Americans, who are scarce in the area, are slowly making history. However, the journey has been gradual and challenging.

As with other African Americans on the East End, the few who achieve success have done it by means of family, faith, and hard work. Most came to the area as migrant workers in quest of a better life. They worked on potato farms, milked cows, and served as domestic servants.

East Hampton was particularly attractive because it had affluent white Americans who settled in the area and provided African Americans with jobs. Prior to Euro-American occupation, Native Americans inhabited East Hampton. A colorful character named Pharaoh is one of the few whom historians have remembered.

In 1648, a handful of English immigrants officially took control of East Hampton and built their cottages on Main Street. These settlers had slaves and migrant workers as servants and laborers.

In the mid-1800s, specifically after the abolition of slavery, a few African American families started coming to East Hampton on a seasonal basis. Most came from North Carolina, South Carolina, and Virginia. By the early 1900s, a number of African American families had settled in East Hampton. Some of these pioneers included the Squire, Marshall, Hartwell, Nicholson, Blowe, Laporte, DeBoard, and Hayes families. Others included the Butlers, the Proyors, the Sylvesters, and the Coopers.

Gradually, African Americans integrated into the community, where they emerged as landscapers, carpenters, farmers, janitors, teachers, police officers, pastors, business executives, and today, judges and administrators. At the same time, sons and daughters of East Hampton families left in search of greener pastures or went off to college and built lives elsewhere.

In 1954, Rev. Ralph Spinner realized the need for a church in East Hampton. A visionary with determination, he moved from Southampton and started Calvary Baptist Church, which thrives to this day. Lee Hayes, a former Tuskegee pilot and a charter member of the church, described him as "a remarkable man," adding that "Ralph Spinner, along with leaders such as Dr. Martin Luther King Jr., had visions which some of us lacked."

In the 1960s, Lucille Teel, a graduate from Virginia, was hired to teach in East Hampton High School. She became the school's first African American teacher. Southampton College graduate Leon Parks was the first school administrator who rose to the rank of vice principal, serving at East Hampton High School. Carrie Gilbert was the second teacher in the area. Today, a number of nurses, educators, administrators, pastors, and lawyers have emerged from East Hampton, many of them going on to serve in other parts of the country.

The current senior citizen center was previously a motel called the Cottage Inn. The motel was managed by Gaines Proyor, one of the early African Americans to run a business. Parties, weddings, and other social functions were held at the Cottage Inn. Another entertainment center, Hotel James, was the site of parties that featured music from hi-fi sets and, occasionally, live bands. Joe Laporte managed a convenience store in the city. Ruth and Lucy Hartwell, who graduated from Orchard Beauty School in New York in the 1940s, operated one of the first beauty parlors on the East End. Today, African American families own land and houses on the East End generally and in East Hampton specifically.

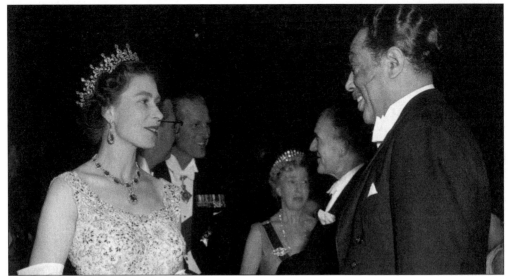

Jazz musician Duke Ellington accepts congratulations and thanks from Queen Elizabeth after performing a concert for her in the 1950s. Prince Philip is in the center background. (Courtesy of Henry Maxwell Letcher.)

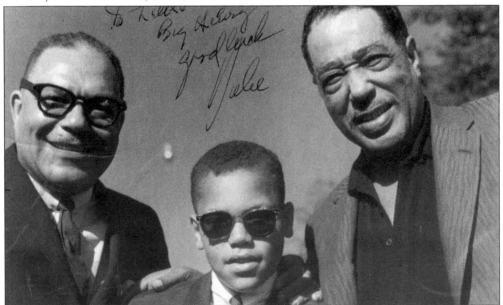

Henry Maxwell Letcher is flanked by his cousin Duke Ellington (right) and his father, Henry Letcher Sr. in this 1965 photograph. After earning a degree in black music, young Letcher taught at Bennington College in Vermont, which established a black music division. He is currently a musician, mentor, and broadcaster-music director of WPBX, Southampton College. His father served in the air force during World War II, in North Africa, Italy, and northern Europe. A lieutenant later promoted to the rank of major, he was a transportation officer with the famous 99 Fighter Squadron—the first and only black pilots unit ever to serve in the U.S. military—which earned the best safety record in the war. Also an artist, whose specialty was ceramics, the father owned a black school in Washington, D.C. His students designed houses, which he then built in Sag Harbor. (Courtesy of Henry Maxwell Letcher.)

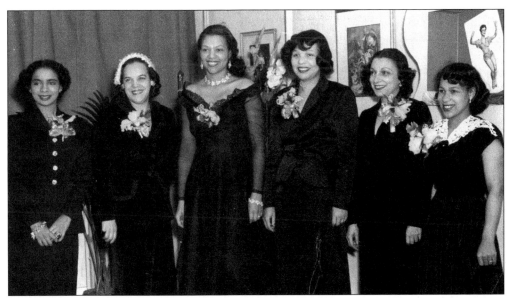

Evelyn Letcher (third from left) and Ruth Ellington appear in this photograph taken in Washington. They met at Henry Letcher Sr.'s school, Letcher Art Center, which opened in 1949. The school taught all facets of commercial art until it closed in 1970. (Courtesy of Henry Maxwell Letcher.)

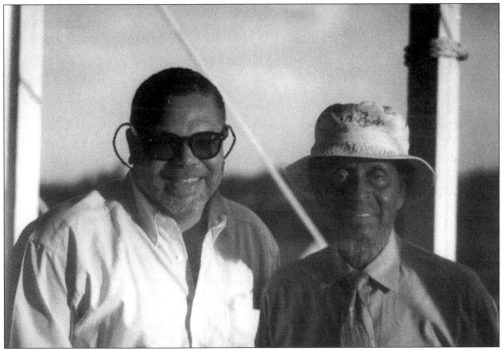

Pictured are Henry Letcher (left) and jazz great Percy Heath of East Hampton. One of the founders of the Modern Jazz Quartet, Heath, in his 80s, was still playing bass and cello and traveling around the world. He has been associated with the Hamptons since his youthful days in the early 1940s and 1950s.

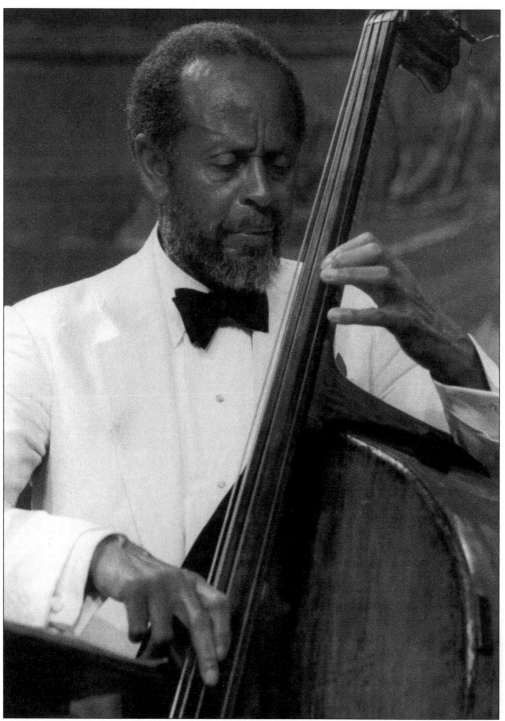

Percy Heath plays with artistry. The East Hampton resident is among the jazz greats of the 20th century. He has performed across the country and throughout the world. He also stages concerts in the Hamptons and is featured prominently on WPBX, the all-jazz station of Southampton College of Long Island University. (Courtesy of Percy Heath.)

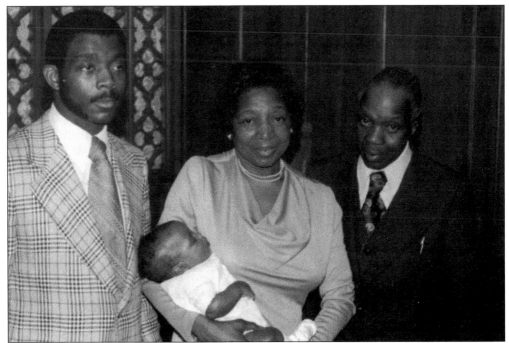

This photograph shows, from left to right, James Nicholson Jr., James Nicholson III, Victoria Nicholson, and James Nicholson Sr. James Nicholson Sr. came from Drewryville, Southampton County, in 1930s. He worked with the railroad, did farming, and drove a truck. He and Victoria met in East Hampton and, after marrying, they bought property on Springs Road and raised a their two children, Rosa Hanna and James Jr.

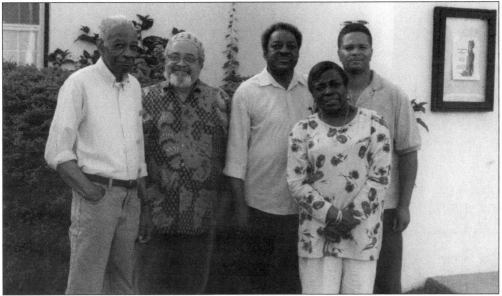

Celebrated artist Rosa Anna Scott (second from right) was born and raised in East Hampton. A respected mother, mentor, and childcare specialist, she taught school on the East End. Currently, she draws, designs, and paints. A naturalist, she focuses on humans, plants, and animals.

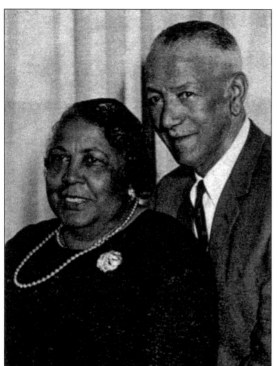

Rev. Ralph Spinner of Southampton was the founding pastor of Calvary Baptist Church of East Hampton in 1954. He organized a meeting in St. Matthew's Chapel on Three Mile Harbor Road, East Hampton, in September 1955. In November 1955, a follow-up meeting with 130 people in attendance was held. That meeting led to the church's birth. Under Spinner's leadership the church bought the present site on Springs Road, East Hampton, and incorporated Calvary Baptist in 1955. Spinner resigned in 1959 but was unanimously recalled as pastor in 1965. (Courtesy of Pastor Hopson and Calvary Baptist Church.)

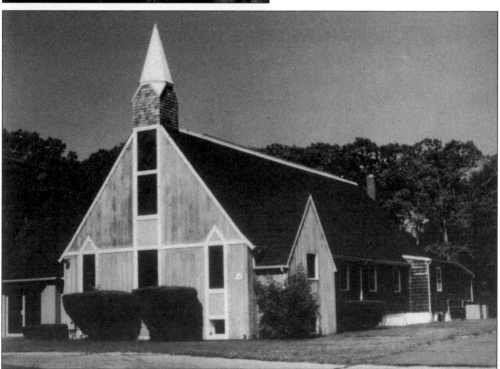

Easthampton Calvary Baptist Church was constructed in the 1950s. The church serves as a community center and attracts prominent East Enders. It is a home church to numerous families.

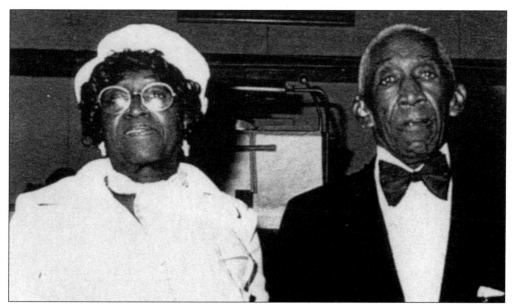

Deaconess Bertha Squire and Deacon Maynard Squire were among the earliest African American couples to settle in East Hampton. They arrived in the early 1900s, bought land, built a house, and raised a family. They were respected church leaders. Their offspring and grandchildren have distinguished themselves in various spheres of endeavor. (Courtesy of Pastor Hopson and Calvary Baptist Church.)

Three distinguished East End residents appear in this photograph. They are, from left to right, educator and community leader Carrie Gilbert, pianist Arthur Davis of the famous Davis family of Southampton, and Eastern Long Island NAACP president Lucius Ware, a retired educator, principal, and school superintendent. (Author's collection.)

Lucille Westbrook Teel distinguished herself as an educator, a poet, and a community affairs participant. She has the distinction of having served as the first African American teacher in East Hampton High, where she taught English for more than two decades. She earned a bachelor's degree from Virginia State College and did graduate work at Hunter College and Southampton College of Long Island University. She served as assistant dean of women at North Carolina Agricultural and Technical State University in the 1950s, before relocating to Long Island. After retiring in 1985, she concentrated on writing poetry. (Courtesy of Lucille Westbrook Teel.)

One of the outstanding educators and community leaders on the East End, Carrie Gilbert of East Hampton served as the second African American teacher at East Hampton High School. Articulate and constructive, she served on the Eastern Long Island Educators Association and the local NAACP Education Committee. A supporter of youth, education, and scholarship, she served as a mentor to numerous African Americans and advocated the hiring of people of color on the East End school system. (Author's collection.)

The Calvary Baptist Church includes members related to the first seasonal migrant workers who eventually settled on the East End in the early 1900s—the early craftsmen, farmers, fishermen, "baymen," and domestic servants. Pictured is the senior choir, which at the time listed the following members: Louise Wilson, Helen Hayes, Hattie Jones, Cheryl Lewis, Evelyn Carter, Sadie Barber, Lois Lane, Evelyn Stephens, Mathalda Haney, James Wood, Clarence Lewis, Jesse Barber, Chester Lane, Alberta Harvey, Lewis Dozier, and Brooks Hires. (Courtesy of Pastor Hopson and Calvary Baptist Church.)

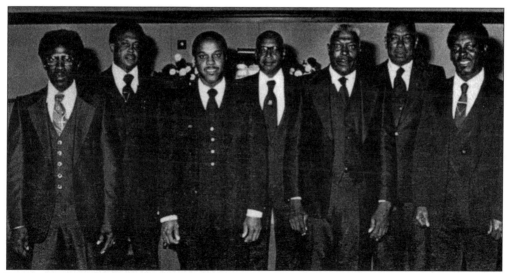

The male chorus of Calvary Baptist Church listed as members the following: Chester Lane, Webster Claud, Henry Haney, Rev. Walsh Jackson, James Turner, James Wood, Clarence Lewis, Brooks Hires, Jesse Barber, Louis Dozier, Timmy Harris, Paul Jones, Melvin Riddick, and David Jackson. (Courtesy of Pastor Hopson and Calvary Baptist Church.)

Robert Hartwell is shown both in his youth (left) and later in life (below). The husband of Lottie Hartwell, he was a mason. The Hartwells came to East Hampton from McKenney, Virginia, c. the late 1920s. Hardworking community leaders, they raised 10 children, including Marie, Bertha, Helen, Lucy, and Willie Hartwell. (Courtesy of Bertha Hopson.)

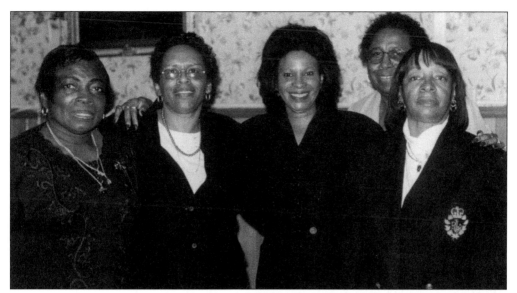

These are some of the East Hampton women who have roots that reach back to the start of the 20th century. They are, from left to right, artist Rosa Hanna, senior citizen center program coordinator Audrey Gaines, Rev. Sharlene Hartwell of Long Island University, educator Carrie Gilbert, and church leader and coach Vivian Graham. (Author's collection.)

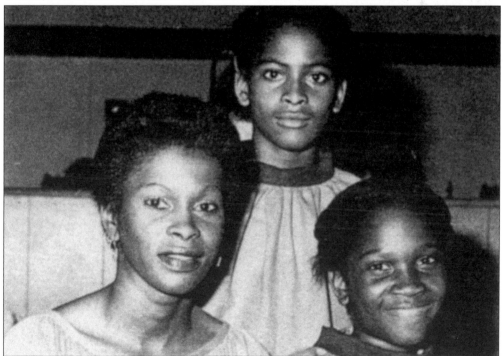

Shown are Rev. Sharlene Hartwell, Adrienne Hartwell, and Carla Hartwell. Prominent in church, social, and cultural activities, they are members of a family that first settled in the area in the early 1900s. Sharlene Hartwell earned a bachelor's degree in communications from Southampton College and a master's degree in theology. She is one the first East Hampton women who trained and earned her license as a Baptist minister. (Courtesy of Sharlene Hartwell.)

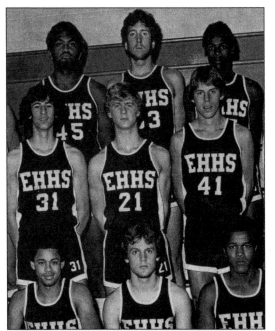

James Howard Wood (back row, left) was born on May 20, 1959, in Southampton Hospital. He graduated from Amagansett School in 1973. He attended East Hampton High School, where he played varsity basketball for three years. In his senior year, he was named to the All-League, All-County, and All-State teams. Wood received a four-year scholarship at the University of Tennessee, where he played basketball for four years. In his senior year, he was an All-Southeastern Conference player and team captain. He was the 27th overall pick in the 1981 National Basketball Association draft. He played for one year with the Utah Jazz and two years in the Continental Basketball Association before embarking on a Spanish League career, which lasted 16 years—11 years of professional play and 5 years of coaching. (Courtesy of James Howard Wood.)

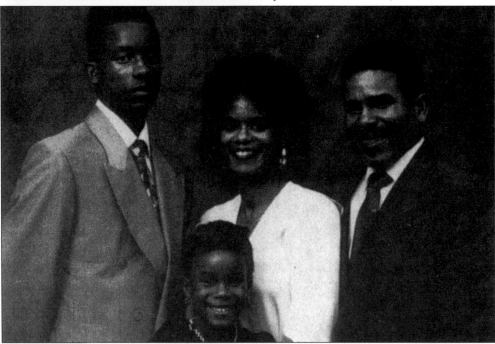

Shown in this family portrait, from left to right, are Charles Earle Hopson II and Shalyn Renee Hopson and their parents Sheila and Charles Earle Hopson. The pastor of Calvary Baptist Church in East Hampton, Hopson works with the Southampton school system. His parents moved to eastern Long Island in the early 1900s. Sheila Hopson, one of the first African American bank managers on the East End, later became secretary at Ross School in East Hampton, where students call her "Mama Love." Her parents migrated to the Hamptons c. the 1920s.

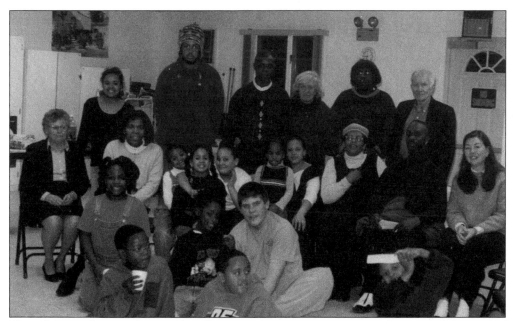

This photograph was taken at East Hampton Senior Citizen Center during a celebration of Black History Month. Audrey Gaines (seated, third from right) coordinated the event. A native of East Hampton, she holds a bachelor's degree from Long Island University and a master's from State University of New York at Stony Brook. (Author's collection.)

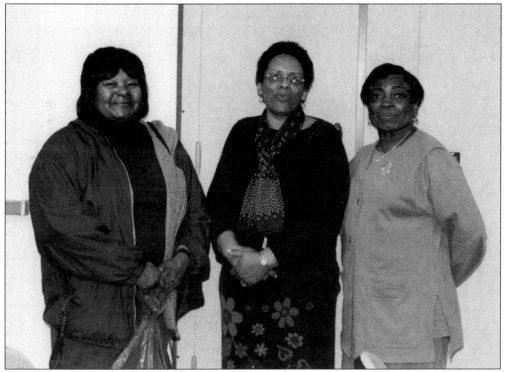

Audrey Gaines (center) directs programs at the East Hampton Senior Citizen Center. (Author's collection.)

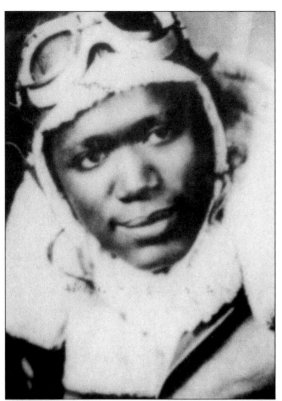

Lee Hayes, a noted community leader in East Hampton, served with the Tuskegee Airmen in World War II. (Courtesy of Lee Hays.)

Lee Hayes was drafted into the army in 1943 and was recruited into the air force in 1944. (Author's collection.)

Henry Haney, a church deacon, has lived in the Hamptons for almost a half century. He hosts a talk show entitled *Tell It to Henry* on LTV. (Author's collection.)

William Hartwell (center) is a youth leader and mentor on the East End. He works with young people, counseling them, coaching them, and taking them on trips. He is shown with his wife (left) and sister-in-law. (Author's collection.)

Queen Davis-Parks beams brightly after receiving her B.A. from Southampton College of Long Island University in 1976. Before earning her degree, she worked as a teacher's aide at the East Hampton Day Care Center. She later obtained a master's degree in science. A teacher at the John M. Marshall Elementary School in East Hampton, she has been honored a number of times for her excellence in teaching. The school district praised her for the way she taught black history, emphasizing her unit on the Underground Railroad. A member of the Hayes family of East Hampton, she is the sister of Lee Hayes.

Leon Parks, husband of Queen Davis-Parks, became the first African American school administrator in the East Hampton School District. The son of John and Lillian Parks, he grew up in public housing and was a member of a group of 50 students that integrated Fort Hamilton High School in Brooklyn in 1962, a previously all-white city school. A 1965 graduate of Fort Hamilton, he demonstrated his teaching skills while still a student by instructing younger children in Sunday school.

Three
THE NORTH FORK
CHURCH AND FRIENDSHIP

The North Fork, with its natural magnificence and charm, also has a rich history. Church, family, and friendships characterize the northeastern stretch of Long Island. African Americans are scattered throughout this relatively serene and rural winegrowing region. Pockets of them reside in Southold, Greenport, Cutchogue, and Mattituck. The Morris, Ford, and Watkins families have been here since the start of the 20th century. The Morris family is an example in which the master-slave relationship ended in friendship and family ties.

The land that is now Southold, like that of other towns on the East End, originally belonged to the Native Americans. In 1640, Puritans acquired the area from Orient Point to Wading River. Corchaug Indians, who called it Yennecott, signed the transfer deeds to these strangers.

In the 1670s, the shipping industry experienced a boom. After it declined, the railroad emerged as a major employer in the 1700s. Work with the railways and farms attracted African Americans. During the Revolution, some Southolders remained loyal to Britain while others fled to Connecticut. However, until the war's end in 1783, the British controlled Southold.

When African Americans started making the area their home in the late 1900s, the need for churches became imperative. Thus, in the 1920s, work was begun toward the formation of churches started in Southold and Cutchogue. Charter members of the two churches were among the earliest of African American settlers. Although businesses thrived, the area remained an agricultural community and African Americans who came to the region worked on farms.

Another major North Fork town where African Americans have a presence is Greenport, which was incorporated in 1838 and emerged as a prosperous whaling port. The African Methodist Episcopal church became the focal point of community life as soon as African Americans made Greenport their home. With the advent of the Long Island Rail Road in 1844, trains carried local farm products to sell in the city. African Americans came to Greenport to improve their economic status.

Like other African Americans on the island, most came from the South in search of a better life. However, since Greenport was a port city, some Africans aboard ships that were on expeditions may also have settled in the area. The original settlers were Native Americans, followed by the first Europeans in 1640. Greenport's strategic location made it an attractive center for commerce, tourism, farming, fishing, and whaling. In 1785, whaling became an important occupation after the Nathaniel brothers and Hudson Corwin equipped a number of small vessels. By 1790, Greenport had grown into a major commercial fishing center. Besides legitimate trade, smuggling was a big venture in Greenport. The arrival of the railroad in 1884 linked Greenport to other parts of the country, attracting African Americans, who easily found jobs in the industry.

First Baptist Church in Cutchogue was built in 1924 by early African Americans settlers. It has always been the dominant institution for the few families who live in town. Pastor Cornelius Fulford heads the Cutchogue congregation. Recently, a new site for the church was identified and fund-raising for its construction got under way.

Unity Baptist Church in Mattituck, built more than 60 years ago, and House of Praise in Jamesport are the leading African American centers in their two towns. Some members of these North Fork churches live in the nearby towns of Riverhead, Southampton, Easthampton, and Moriches. Marvin Dozier of Southampton is the current pastor of Unity Baptist Church. Although some African Americans live in these towns, others come just to work, pray, or play and then return home at the day's end.

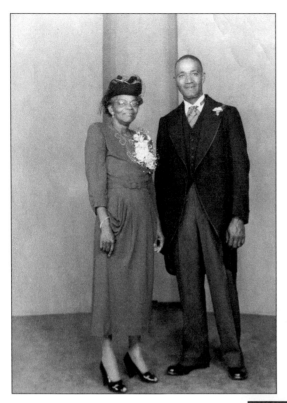

George Thomas Morris was one of the first African Americans to settle in Southold. He and Anna Falcon Morris (pictured) arrived in Westhampton in 1912 to work on farms. In 1920, they moved to Southold to work on the Benjamin Tuthill farm. They were instrumental in building Shiloh Baptist Church. They had seven children: Levai, Alice, twins Daysman and Vincent, Eleanor, and Virginia. Today, Daysman Morris owns a modern house at the Tuthill farm site. (Courtesy of Daysman and Nan Morris.)

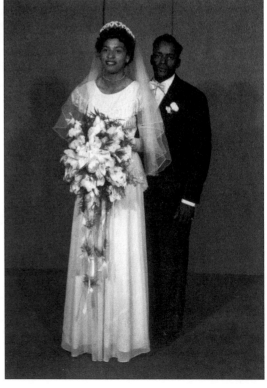

Daysman Morris and Nan Morris were married in August 1949. The son of Anna Falcon Morris and George Thomas, he was born in 1924. He developed a successful cesspool business, which is still in operation today. A prominent church leader and respected voice in the community, he was the first African American to serve as the president of Southold Rotary. Nan Morris was born in 1930 in Greenport to James and Pearl Morris of Emporia, Virginia, who had come to Cutchogue in 1925 to work. She attended Cutchogue Elementary School and graduated from Greenport High School in 1948. (Courtesy of Daysman and Nan Morris.)

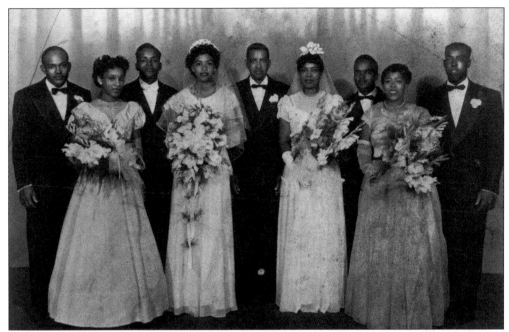

Friends and family gather at the wedding of Daysman and Nan Morris. They are, from left to right, Clarence Morris, brother; Lucy Touissant, friend; the groom; the bride; James Morris, the bride's father; Mattie Johnson, the bride's sister; Vincent Morris, the groom's twin brother; Eleanor Lingo, the groom's sister; and Leslie Bates, the groom's friend. (Courtesy of Daysman and Nan Morris.)

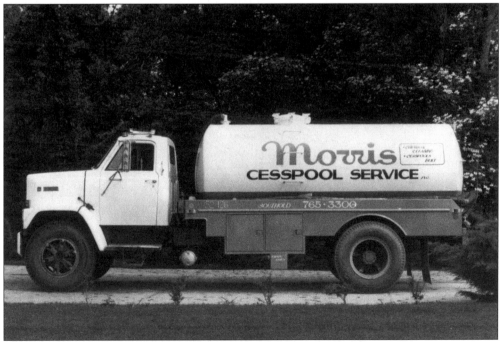

Morris Cesspool Service, was started in the 1950s. It prospered and is still in business, managed today by the son of founder Daysman Morris. (Courtesy of Daysman and Nan Morris.)

Pastor Percy Tamm was one of the respected clerics on the East End who served Shiloh Baptist Church in Southold. He was pastor, associate pastor, and pastor emeritus for over half a century. (Courtesy of Pastor Edmond and Shiloh Baptist Church.)

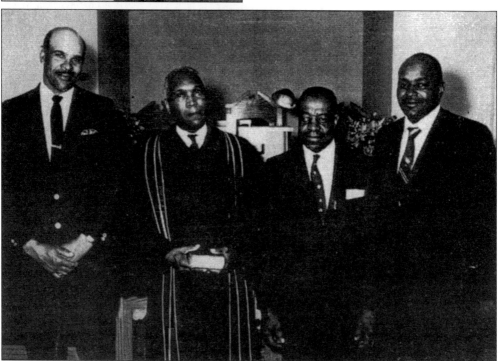

Pastor Percy Tamm (second from left) poses with other leaders of Shiloh Baptist Church leaders, all of whom belonged to early African American families of Southold and the East End. This photograph was taken in the 1970s. (Courtesy of Pastor Edmond and Shiloh Baptist Church.)

Wayland Jefferson distinguished himself as the first African American town historian in Southold. After graduation from high school, he proceeded to Columbia University, where he earned his master's degree. He served as the town historian without pay from the 1930s to 1960—the year he received his first payment for the job. (Courtesy of the News-Review.)

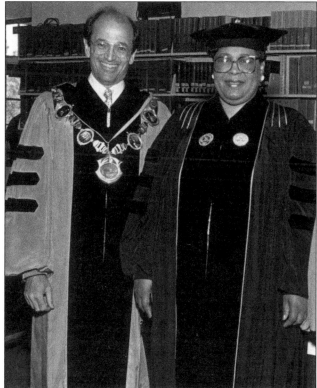

Bessie E. Swann, recognized on Long Island and throughout the entire state for her efforts in fighting against poverty and discrimination, receives an honorary doctorate degree from Southampton College, Long Island University. With her is Long Island University President Dr. David Steinberg. Associated with the area for more than 50 years, she attended school in Greenport, chaired the Greenport Community Development Committee/Greenport Task Force for Racial Unrest, and served for 11 years as the executive director of the Community Action Southold Town (CAST) and the director of the Greenport Housing Alliance. (Courtesy of Southampton College Public Relations Office.)

Josephine Watkins was the first African American to be licensed as a cosmetologist in Greenport. She graduated from Greenport High School in 1940, becoming the first member of her family to earn such a distinction. Taken in the 1950s, this photograph shows her holding a baby named Gina Adams. (Courtesy of Josephine Watkins.)

Ralph Watkins was one of the first African American postal workers in Greenport. He married Josephine Watkins and they raised two sons and a daughter. They were also among the first African American Lutherans in the area. (Courtesy of Josephine Watkins.)

Lelia Hamilton was the first African American schoolteacher in Greenport. She later taught in Riverhead. She is pictured in air force uniform in 1952. She was the second African American woman to graduate from the Officer Candidate School at Lackland Air Force Base, Texas. (Courtesy of Lelia Hamilton.)

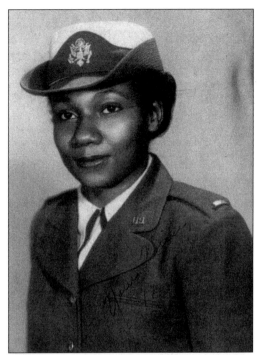

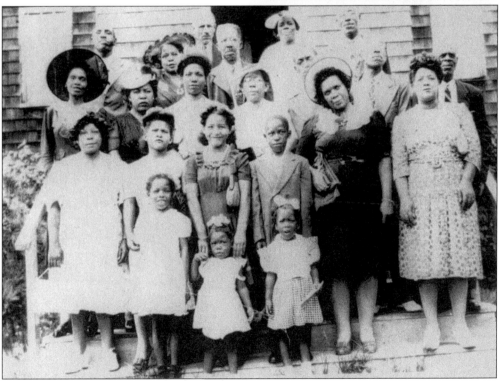

Shown are founding members of Cutchogue First Baptist Church. They were among the early African Americans to settle in the area. (Courtesy of Pastor Cornelius Fulford and Cutchogue First Baptist Church.)

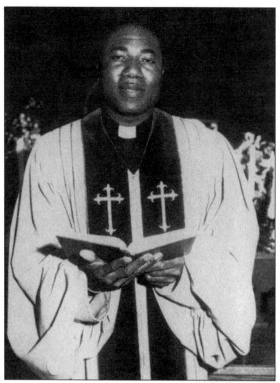

Pastor Cornelius Fulford of Cutchogue First Baptist Church has for the past four decades played a prominent role in the community. In his earlier days, he was a musician with a popular East End group. (Courtesy of Pastor Fulford and Cutchogue First Baptist Church.)

Viola Cross, an evangelist, was one of the first nurses from the East End. (Courtesy of Pastor Fulford and Cutchogue First Baptist Church.)

Kevin Ford, a church deacon, was the first African American postmaster from the town of Cutchogue, where his family has lived since the beginning of the 20th century.

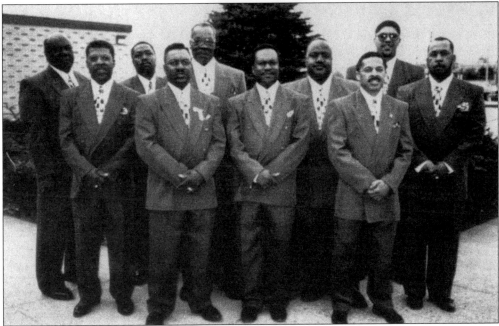

Members of the Keys of Heaven of Cutchogue First Baptist Church are dressed in double-breasted suits and matching ties. They are, from left to right, John Ford, Melvin Hubbard, Michael Hubbard, Russell Langhorne, Russell Smith, Clyde Ross Sr., James Hubbard, Richard Turpin, Kevin Ford, and Gary Langhorn. The Fords and the Hubbards have family histories on the East End dating back to the early 20th century. (Courtesy of Pastor Fulford and Cutchogue First Baptist Church.)

Judge Maryette Cooper-Upshur (above, center) graduated from Riverhead High School and became one of the first African American judges from the East End. She is the mother of three children (above) and a prominent member of the Jamesport church House of Praise. Her mother, Mary Cooper (above left, and left), is the pastor of House of Praise. (Author's collection.)

Rev. Mary Cooper (back row, right) became one of the first African American female pastors on the East End. Her church, House of Praise, is located in Jamesport. She belongs to the Bell family of Riverhead, known for their work in community development. (Author's collection.)

This group attracts gospel singers who have performed in church, choral, and community groups for the last 50 years. All of its members have roots on the East End. They sing in clubs and at weddings, parties, funerals, and other functions. (Author's collection.)

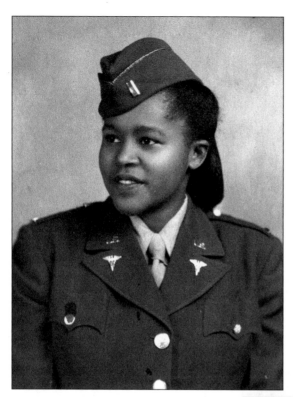

Vivian Booker Leonard served as a lieutenant in the army. She was one of the first lieutenants from the East End. (Courtesy of Carole Booker Joynes.)

Edwin German of the East End was in the Marines and served in the Vietnam War. He is a well-known artist and jazz disc jockey with Southampton College radio station WPBX. (Courtesy of Edwin Germain.)

Members of the First Baptist Church choir trace their family roots in the North Fork back to the early years of the 20th century. (Author's collection.)

First Baptist Church leaders have strong family ties in the North Fork. (Author's collection.)

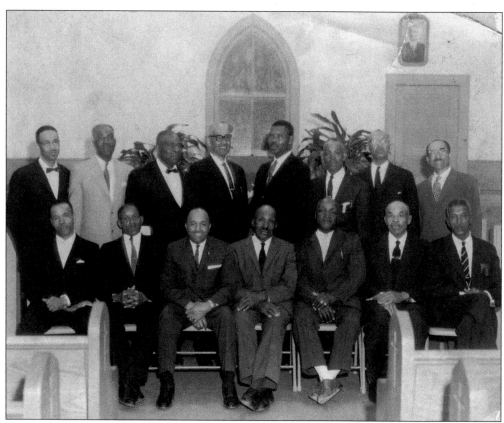

Shown in this *c.* 1950 photograph are church and community leaders of the East End. They are, from left to right, the following: (front row) Bill Wyche, unidentified, Wesley Brown, Joe Brown, and three unidentified men; (back row) John Hale, Cornelius Jackson, ? Bell, two unidentified men, Woodrow Hobson, and two unidentified men. (Courtesy of Carleton Seay.)

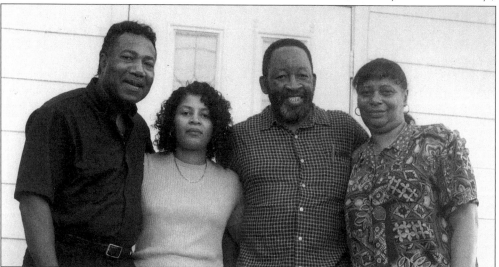

Relaxing with their wives are the pastors of two Baptist churches, Rev. Cornelius Fulford (left) and Rev. Edmond. (Author's collection.)

56

Four
RIVERHEAD
AFFLUENCE AND POVERTY

Riverhead has an interesting history. Originally a part of Southold Hamlet, it was decreed as the seat of Suffolk county government in 1727 and was officially laid out in 1792. After the American Revolution, it became the 10th Suffolk town. After looking at the Peconic River, John Tucker and Joseph Horton of Southold sought permission to build a sawmill in Riverhead and c. 1659, they were authorized to do so. These two men became the first white settlers in the town.

The 18th century witnessed Riverhead's prosperity, as quite a few industries—notably textiles, shipbuilding, cigar, button, and chocolate production—boomed. It was also a fertile area for cranberry and potato farms. Potatoes emergence as the major crop in the 1880s coincided with the post-Civil War's abolition of slavery and the migration that resulted from subsequent developments.

Political and economic factors spurred African Americans to move from the South to the North in search of greener pastures. A significant number—particularly from the states of Virginia, and North and South Carolina—migrated to Riverhead and Long Island in general, first as seasonal workers and later as permanent residents. A number of African Americans from Powhatan, Virginia, made Riverhead their home, and to this day many African Americans still have homes and families in the south.

The early 1900s had transformed Riverhead into a vibrant commercial and agricultural center with large potato and duck farms. Many African Americans who initially came on a seasonal basis and eventually settled in the area worked on these farms. In 1863, Riverhead formed the Farmers Club, which emerged as America's oldest cooperative. It was dissolved in the 1950s.

Today, Riverhead prides itself for having a modern aquarium, an outlet center, and a water park. Although government offices were relocated to Hauppauge and other places, Riverhead is still the county seat. The African American presence is quite visible, but integration in the mainstream community progresses gradually. African Americans have made significant progress in all sectors of the economy, yet many still languish in the lower rungs of the socioeconomic ladder.

Notwithstanding, Riverhead like most communities has its own distinguished sons and daughters. A few have excelled in the military, the ministry, and in other services. The statue of Garfield Longhorn in front of town hall testifies to one man's contribution to the military. Other residents have become lawyers and judges, pharmacists and managers, business executives and civil leaders in the city and elsewhere. Most have moved to other states and parts of the world, where they bequeath lasting legacies in all fields of human endeavor. The photographs in this section provide some landmarks, personalities, and portraits of historical significance.

The Helms family was one of the first African American families to settle in the area. Early members of the family helped build Goodwill Zion African Methodist Episcopal Church on Flanders Road, which is one of the oldest churches on the East End. The church's current fellowship hall was once a restaurant owned by Jesse Helms, the father of the Helms sisters, from left to right, registered nurses Elsie and Myrtle, and Anna Mae. The Helms children and grandchildren have distinguished themselves in various areas of community life in New York and elsewhere. (Courtesy of Elsie Helms Manley.)

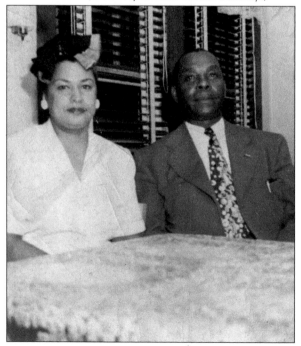

Myrtle Helms Skeete was one of the first registered nurses on the East End. Her husband, Dr. Curtis T. Skeete, was not only one of the first African American medical doctors in the area but also pivotal in establishing the Eastern Long Island Chapter of the National Association for the Advancement of Colored People (NAACP). This 1945 photograph was taken during a community event in Greenport. (Courtesy of Charles Skeete.)

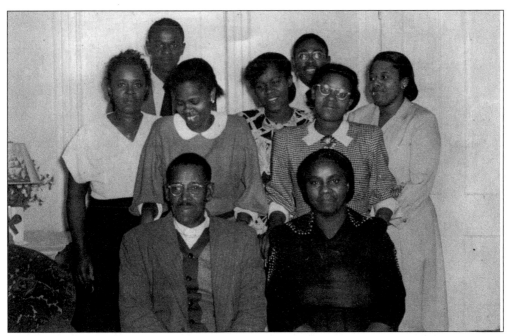

The Bookers were among the first African American settlers on eastern Long Island. Fletcher J. Booker and wife (front row) bought tracks of land on Northville Turnpike in Riverhead, where they built houses for rent. Their children, behind them, are, from left to right, Edith Booker Brown, one of the earliest African American hairdressers on the East End; James Booker, a journalist and public relations executive, who served as White House press officer during Pres. Lyndon Johnson's term; Ruth Booker, a home care specialist; Vivian Booker Leonard, a nurse; Raymond Lee Booker, an Internal Revenue staff member; Carol Booker Joynes, a school nurse; and Harriet Booker Johnson, a hairdresser. This photograph dates from 1955. (Courtesy of Carol Booker Joynes.)

Shown are James and Jean Booker and their son James Booker Jr. A distinguished journalist, commentator, and public relations expert, Booker attended Hampton University in Virginia and graduated from Howard University. In the 1960s under Pres. Lyndon Johnson, he served as a press officer. He worked as a print and broadcast journalist before becoming a syndicated columnist. Jean Booker worked as a journalist, a community leader in Harlem, and a mentor. The son became a Methodist minister. (Courtesy of Carol Booker Joynes.)

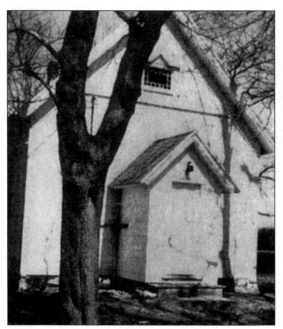
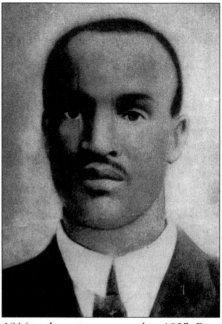

First Baptist Church of Riverhead was established in 1916 and was incorporated in 1927. Rev. William C. Harris (right) was the first pastor of the church. This picture of him dates from 1918. The W.C. Harris Fellowship Hall is named in his memory. (Courtesy of Pastor Coverdale and First Baptist Church.)

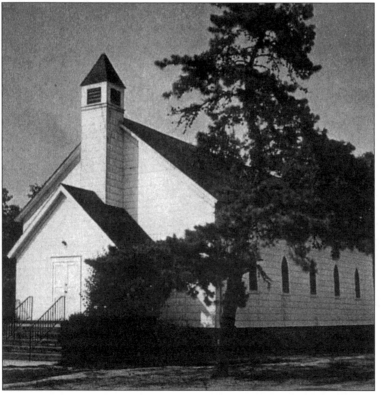

This was the second place of worship for First Baptist Church of Riverhead. The Church, which recently celebrated its 75th anniversary, is one of the leading institutions in eastern Long Island. (Courtesy of Pastor Coverdale and First Baptist Church.)

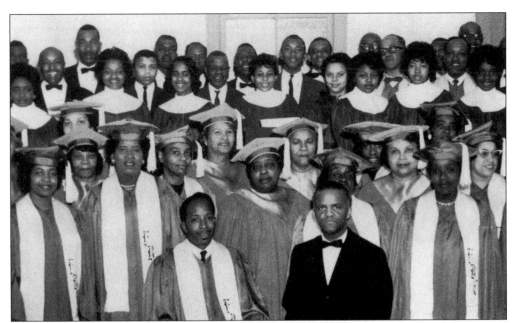

Joseph Brown (left) and Rev. Theodore Hubbard sit in front of the choir of First Baptist Church of Riverhead c. 1950. The choir has been a prominent gospel group since 1940. Its members include singers from families with a long history on the island. (Courtesy of Joseph Brown.)

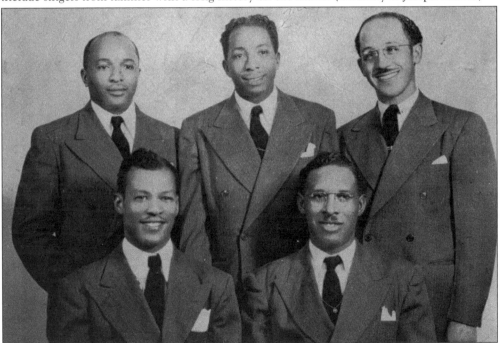

From the 1940s to the 1980s, the Pilgrim Travelers performed in churches throughout New York, New Jersey, and Connecticut. Members were, from left to right, as follows: (front row) Samuel Woodson and Nathaniel Johnson; (back row) Wesley Brown, Joseph Brown, and Stewart Harris. The Browns were among the first African American families to settle on the East End. (Courtesy of Joseph Brown.)

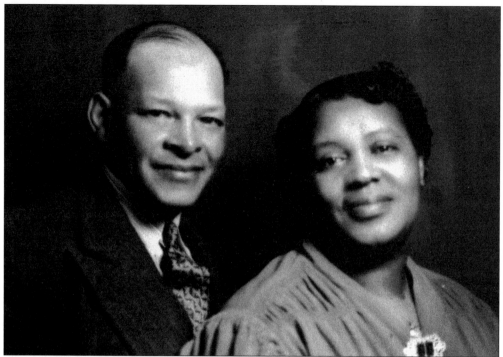

Harry and Eunice Nelson met in New York City and later moved to Riverhead, where they settled in the early 1900s. A fisherman, Harry Nelson ran a successful trucking business throughout Long Island. The couple raised children who successfully entered the business world, social work, the military, and the church. (Courtesy of Ruth Smith.)

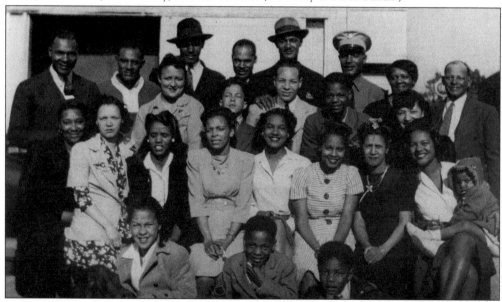

The Nelsons are one of the largest families in Riverhead. They have distinguished themselves in community, church, and business life. Harry Nelson founded Nelboro Trucking. Ruth Nelson Smith established a successful beauty salon. Other Nelsons include a pastor and two members of the military. This photograph dates from c. 1950. (Courtesy of Betsy Crump.)

In 1951, Albert Seay Sr. opened one of the first African American-owned funeral homes at 711 Harrison Avenue in Riverhead. Born in Cartersville, Virginia, in 1919, he excelled as an athlete at Riverhead High School, graduated in the 1940s, enrolled in the army, and trained as an officer. During World War II, he was a lieutenant and platoon leader serving in Italy (1941-1946). He was shot and suffered serious injuries. However, rather than let his subalterns carry him from the danger zone, Seay ordered them to retreat and he literally crawled until he reached safety. He was awarded the Silver Star for gallantry and a Bronze Medal for heroism. In 1946, he graduated from Eckel's College of Mortuary Science in Philadelphia. In 1976, he earned a master's degree in social work from State University of New York at Stony Brook. In 1980, he received a master's degree from New York Theological Seminary. (Courtesy of Carleton Seay.)

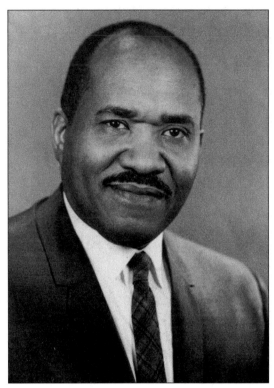

Carleton Seay, son of Albert Seay Sr., attended mortuary school, earned his certificates, and took over his father's funeral home business. Active in the Masonic Order, he and Albert Seay became the first father and son in the Lodge. He is a member of First Baptist Church of Riverhead and has worked with Suffolk County Hospital for nearly three decades. (Courtesy of Carleton Seay.)

The Crumps are a prominent Riverhead family with a record of distinguished professional and community service. The elder Crump was one of the first elected officials from the town of Riverhead. He was the first African American town assessor. He later served the city of Huntington in the same capacity. Betsy Crump was also one of the pioneer African American teachers in the area. Their son Dr. Anthony Crump (far left) excelled as a Riverhead High School student and quarterback on the football team. After earning his medical degree, he moved to Atlanta and began practicing medicine. (Courtesy of Charles and Betsy Crump.)

In the early 1900s, members of the Nash, Hopson, and Brown families became among the first African Americans to settle in Riverhead. Like most of the early immigrants, they worked in farms and did odd jobs. They also bought land, built houses, and became successful residents. Pictured, from left to right, are some members of the three families: (front row) Blanche Baskerville, 90-year-old Rebecca Nash of Osborne Avenue, Lucy Primm, and Hazel Hopson; (back row) Debra Brown, Andrew Nash, Marion Koonce, Barry Bell, Shirley Nash, Marshall Nash, and Woodrow Hopson. (Courtesy of Rebecca Nash.)

Andrew and Rebecca Nash started and operated one of the first African American cesspool businesses in Riverhead, which their son Marshall Nash now manages. They came from Virginia in the early 1900s and first lived on Sound Avenue. They were active in First Baptist Church of Riverhead, where family members still worship. (Courtesy of Rebecca Nash.)

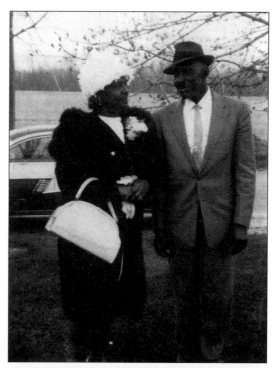

Gathering for this photograph are some of the pioneer African American educators on the East End. They are, from left to right, as follows: (front row) Ben Butler, basketball coach at Riverhead High School; and Lorraine Taylor; (back row) Charles Crump, town assessor; Carrie Gilbert, the second teacher in the East Hampton school system; Lelia Hamilton, the first teacher in Greenport and one of the first teachers in Riverhead; and Marion Johnson, one of the first teachers in the Pulaski School in Riverhead. (Courtesy of Lelia Hamilton.)

James Richardson (middle row, second from right) sits with other members of his class at Suffolk County Sheriff's Department Academy. After graduation from Eastport High School in 1965, he served in the air force from 1965 to 1969. He joined the Department of Corrections in 1971, graduated from the department academy, and rose to the rank of deputy warden in 1989. He was the first African American to serve as deputy warden, and in that position he became the highest-ranking African American law enforcement officer in Suffolk County. He retired in 1997. (Courtesy of James and Cynthia Richardson.)

Cynthia and James Richardson of Riverhead (front left and center, respectively) sit for a portrait with their family. Cynthia Richardson has served in a public relations capacity at Suffolk County Community College, and with Eastern Long Island Black Educator's Association, the league of Women Voters, and other community organizations. Lined up in back, from left to right, are sons Jason, James Jr., and Demetrius Richardson, with daughter-in-law Tamala standing in front of her husband. (Courtesy of James and Cynthia Richardson.)

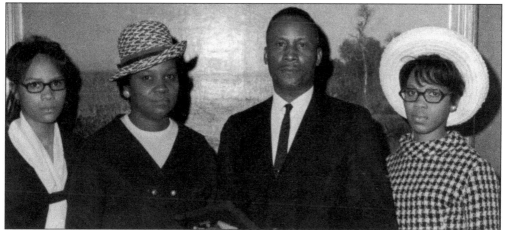

Mary and Garfield Langhorn (center) accept the Congressional Medal of Honor for their son, Garfield Langhorn, in 1970. The Vietnam War hero died to save the lives of his fellow soldiers. With their parents are daughters April (left) and Yvonne Langhorn. The Langhorns came from Virginia in the 1940s and settled in Riverhead. Respected and admired community and church leaders, they worked hard and built their home on Raynor Avenue in Riverhead. (Courtesy of Garfield and Mary Langhorn.)

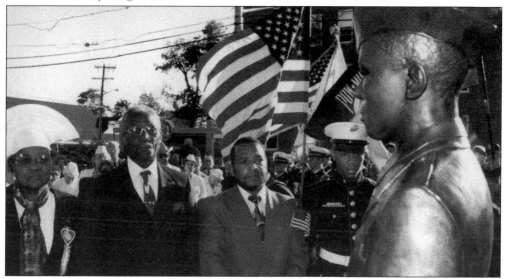

Born in 1948, Garfield Langhorn served in Vietnam as a radio operator in the army's aviation branch. In 1969, after searching for and finding no survivors of a helicopter crash, he and his fellow rescuers were attacked by North Vietnamese soldiers. Langhorn radioed for support, but darkness descended quickly. Suddenly, the attackers launched a grenade. Langhorn threw himself on it, taking the full blast and thereby saving the lives of several wounded comrades. This bronze bust of Langhorn—one of the few monuments that honor people on the East End—sits in front of Riverhead Town Hall. Attending the dedication ceremony in 1993 are, from left to right, parents Mary and Garfield Langhorn and best friend Eugene Robinson. For his supreme sacrifice, Langhorn was posthumously awarded the Congressional Medal of Honor. He was inducted into the Army Aviation Hall of Fame, one of only 75 outstanding soldiers so honored. In addition, a memorial library at First Baptist Church of Riverhead was dedicated to him. (Courtesy of Garfield and Mary Langhorn.)

Pictured in uniform, John Mitchner served in the navy during the Vietnam War. After being discharged, he enrolled in State University of New York at Stony Brook, and earned his medical degree, specializing in pediatrics. Today, he is a pediatrician in Riverhead. (Courtesy of Lolita and John Mitchner.)

This photograph shows Lolita Mitchner, the daughter of Dr. John Mitchner, as a girl of six or seven. Today, she is Dr. Lolita Mitchner, an East End psychologist. She is also the founder of the young women's group Sister Sister, which awards scholarships, mentors students, and promotes professionalism among East End residents. The group also organizes fashion shows, dances, and other social functions. (Courtesy of Lolita and John Mitchner.)

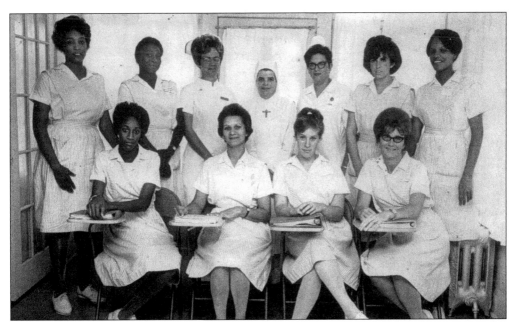

Rena Thompson (standing, second from left) was one of the pioneer African American nurses from Riverhead. She worked in several East End hospitals for almost four decades. She and her husband came to Riverhead from Florida in the early 1950s and settled on Vail Avenue. They joined Goodwill African Methodist Episcopal Church, and she served as one the church leaders. (Courtesy of Rena Thompson.)

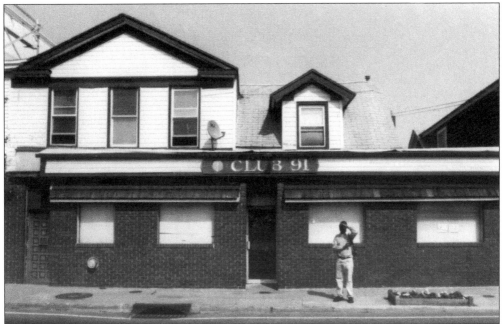

For some time, Club 91 was a popular bar. However, problems arose and authorities had to close it. Today, Club 91 is one of the few social and community halls in the area. It serves as a meeting venue as well as a center for parties and other celebrations. It has a kitchen, a dancing or meeting hall, and a pantry. (Author's collection.)

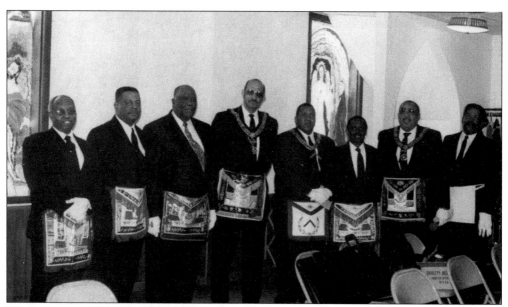

These are some of the members of the Masonic Lodge in Riverhead, from left to right, Richard Liggon, Arthur Anderson III, Anthony Brown, Larry Toler, Leslie Moore, Willie James, Charles Hall, and Tony Walker. Founded in 1948, the lodge awards scholarships, organizes community and social events, and promotes worthy causes. It attracts prominent community leaders, some of whom have a long history in the area. (Author's collection.)

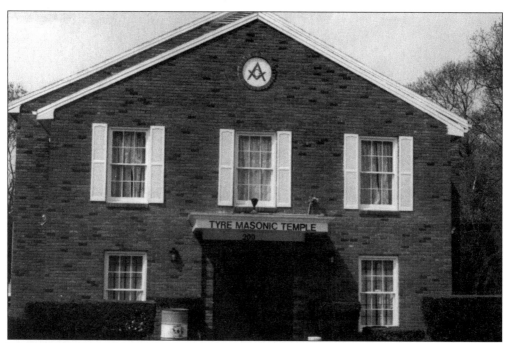

The Masonic Lodge on Flanders Road is a community hall on the East End in which members and community people hold meetings and social functions. It is used by youth and elders as a center for organizing weddings, parties, and other ceremonies. A handsome brick building, it is open to the public with the permission of the lodge leaders. (Author's collection.)

William and Margaret Booker came to Riverhead in 1910. They were farmers who lived in Mattituck before settling in Riverhead. They raised 10 children: William, Margaret, Hardaway, Julia, Warren, Albert, Thelma, Edward, Hillie, and Hazel. (Courtesy of Hillie and Thelma Booker.)

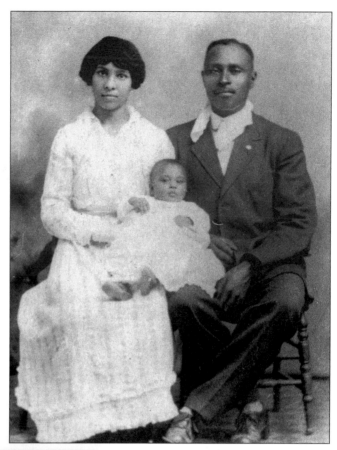

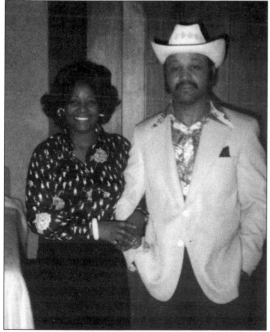

The Booker family has a long history in the region. Hillie Booker, one of the five sons of William and Margaret Booker, is married to Thelma Booker. He worked in construction from 1953 to 1990. She worked with Suffolk County Health Department. Leaders in church and community activities, they have three children, JoAnn, Michael, and Tony. (Courtesy of Hillie and Thelma Booker.)

Denise Lowe became the first female African American to serve as a principal in Riverhead. She earned her Ph.D. from Teachers College Columbia and served as vice principal of Riverhead High School. Prominent in church and community activities, she is the current vice president of the Eastern Long Island Black Educators Association. (Author's collection.)

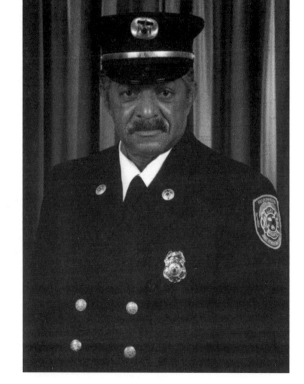

Richard Liggon was born and raised on the East End and served in the U.S. Army. He became the first African American fire chief of Riverhead. He was also one of the first African American postal workers in the city.

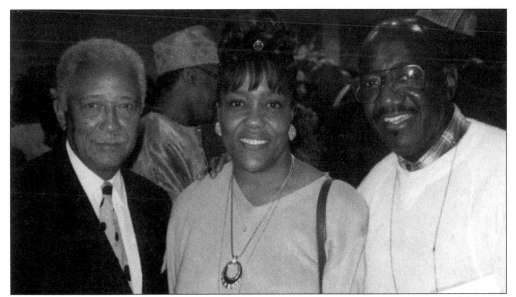

Pastor Charles A. McElroy (left) of Friendship Baptist Church in Riverhead and his wife, pianist and musician MaryAnn McElroy, share a few words with former New York Mayor David Dinkins. McElroy, who holds a master's of divinity degree from Virginia Union University, has led the church for the past 30 years. Each year, under the leadership of MaryAnn McElroy, the East End Arts Council organizes a concert, which draws singers from all sectors of the East End. One of the area's major autumn highlights, the concert shatters the ethnic barriers that occasionally pose prejudice. (Courtesy of Pastor and MaryAnn McElroy and Friendship Baptist Church.)

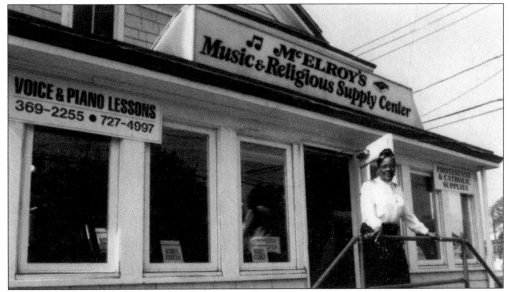

MaryAnn McElroy has a master's degree in voice from the Julliard School of Music and has taught at Virginia State University. Besides her role as choir leader at Friendship Baptist Church, she delivers speeches, teaches voice, tutors persons learning piano, and manages McElroys's Music & Religious Supply Center in Riverhead, one of the few African American-owned businesses in the city. (Author's collection.)

St. Paul's Church in Riverhead is one of the newest churches in the area. The building is a former factory on Ludlam Avenue that was remodeled into a church. St. Paul's is a growing church that attracts youth. It is led by Elder Glenwood Morris and his wife, Deborah Morris, who are pictured with their son Glenwood Morris Jr. (Courtesy of Pastor and Mrs. Morris and St. Paul's Church.)

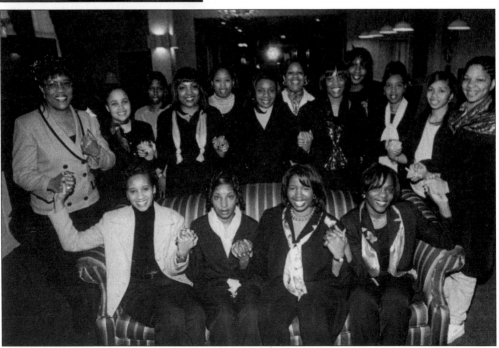

Sister Sister is a group of professional and progressive young women on the East End. MaryAnn McElroy (far right) serves as the mentor. Dr. Lolita Mitchner and Yolanda Jackson are co-leaders. The group awards scholarships and serves as a support network and leadership-training forum. Most members were born and raised on the East End. (Courtesy of the News-Review.)

David Jones Fitzgerald was a well-liked and successful businessman in Riverhead. From the 1930s to the 1960s, he bought land, built houses, and managed the bar Highway 24. He developed and rented property on Flanders Road. (Courtesy of the Fitzgeralds.)

Mrs. David Jones Fitzgerald (left) stands with her only son and his bride at their wedding. The couple live on Flanders Road. He is an accountant and his wife, Marianne, is a member of the Seymour family and works with school system. (Courtesy of the Fitzgeralds.)

Daisy and Lloyd Lewis Seymour first came to the East End as seasonal workers. He worked as a truck driver hauling potatoes during the potato season. This photograph dates from *c.* 1950. (Courtesy of the Fitzgeralds.)

Felicia Annette Williams (second from right) poses with her mother and brothers. She has lived in Riverhead for almost five decades. A salesperson with Fidelity National Title Insurance Company, she is a leader in First Baptist Church of Riverhead. (Courtesy of Felicia Williams.)

Rev. Charles Alfred Coverdale is one of the foremost African American leaders on the East End. Ebullient and humorous, he is pastor of First Baptist Church of Riverhead, one of the largest churches on the island. A Harvard graduate, he has assumed leading roles in local, regional, and international events. (Author's collection.)

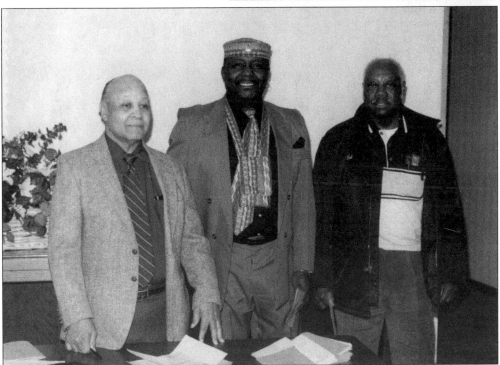

Professor Jim Banks, director of multicultural affairs at Suffolk Community College, is flanked by Deacon Obie (right) of First Baptist Church and community leader Hillie Booker. Booker was the first African American quarterback at Riverhead High School. (Author's collection.)

Karen J. Faber-Womack was one of the first African American female police officers in Riverhead. She graduated as the only minority member of the Suffolk County Police Academy Class of 1984. She earned honors as a distinguished pistol expert with Riverhead Police Department in 1997. Currently, a senior parking enforcement officer and the coordinator of security with Riverhead Free Library, she has served the department for almost two decades. She is married to Troy Womack, and they have three children, Troy, Arthor, and Charles. (Courtesy of Karen J. Faber-Womack.)

Arthor Faber, son of Karen Faber-Womack, is the owner of Platinum Hits I & II. At his shop, which is located in Riverhead, he stocks CDs, cassettes, and clothing. He is one of the few African American youth who manage shops in Riverhead. (Courtesy of the News-Review.)

Curtis Highsmith (front left) worked in the local hospital when he first came up from the South. A talented singer, he started a group and entertained people on the island. At one time his group was called Little Curtis and the Reflections and at another time, Little Curtis and the Big Men (pictured). An astute businessman, photographer, and impresario, Highsmith, with the help of his wife, manages one of the few African American stores on Main Street. (Courtesy of Curtis Highsmith.)

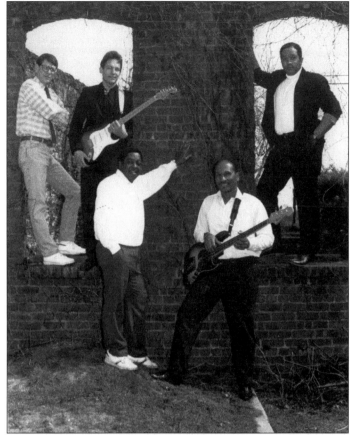

The choir of St. Paul's Church, which draws members from all over the East End, has developed a reputation for excellence. Elder Morris, born and raised in Southampton, leads the youthful and active church. (Author's collection.)

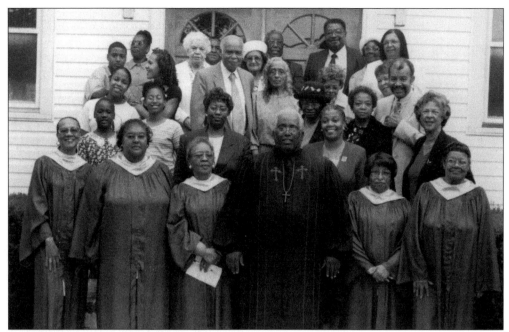

Goodwill Zion was the first African American church established in Riverhead, back in 1872. Its devoted membership attracts some of the oldest and most eminent Riverhead residents, including the Booker, Nelson, Helms, and Crump families. Rev. Gregor Miles (front center) led Goodwill Zion African Methodist Episcopal Church in the late 1990s. (Author's collection.)

O.J. Bright was born and raised on the East End. She began singing in church when she was a child, and she continues to do so. A pianist and organist, she is the official musician of Goodwill Zion African Methodist Episcopal Church and of the Greenport church. Her powerful voice is well known throughout the island. (Author's collection.)

East End resident Sgt. Maj. Shelby Clark fought in World War II, the Korean War, and the Vietnam War. He is among those who would like to see a local monument for Vietnam War veterans built. (Courtesy of the News-Review.)

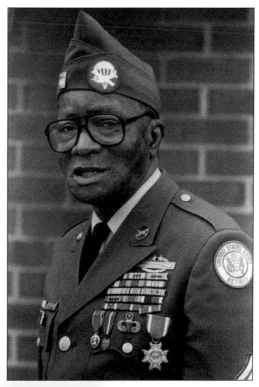

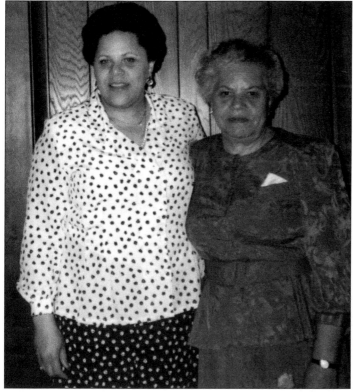

Geraldine Owens (left) and her mother, Elsie Manley (right), were among the first local mother-daughter pairs to serve as nurses at Riverhead Hospital. Both women are prominent in church and community activities. (Courtesy of Jerry and Elsie Manley.)

Rani Carson of Riverhead is a professor at Suffolk County Community College, an art gallery director, and an artist. She depicts people, landscapes, and natural settings with emotional power. In *Sistren*, a 30-by-20-inch gouache, she portrays Africans from the West Indies. (Courtesy of Rani Carson.)

Artist Rani Carson portrays people of African descent in a multiple context. In this work, *Mother's Milk*, she captures the black experience in Jamaica with exceptional colors and a touch of realism. (Courtesy of Rani Carson.)

Five
SAG HARBOR
WEALTH AND FAME

Sag Harbor has over the years attracted wealthy African Americans. Educated and achievement-oriented, these retired and active professional people settled in the neighborhoods of Azurest, Chatfield Hills, Hillcrest Terrace, Ninevah, and Sag Harbor Hills. It is one of the unique towns where black teachers, judges, journalists, businesspeople, and officials interact.

The gorgeous landscapes, magnificent edifices, and famous names associated with Sag Harbor evoke the realities of the American dream. They offer proof that, despite the challenges African Americans still face today, some enjoy abundance and affluence in "God's own country."

Popular and respected personalities, such as *Black Enterprise* publisher Earl Graves and *Essence* editor Susan Taylor, own homes in the area. Others, including Rae Parks, Gloria Hudnell, the Eberhardts, the Carters, and the Lindsays, live here year-round.

Sag Harbor has an interesting history dating back to the 1500s. Historical accounts, however, vary as to when the first African Americans came to Sag Harbor. Some historians assert that Africans, a part of exploration expeditions, made Sag Harbor their home when they debarked from ships. Others suggest that the first ones were brought to Sag Harbor in slave ships. The 1839 Amistad incident, in which African slaves revolted against their masters, indicates that some might have debarked in Sag Harbor. Additionally, the Zion African Methodist Episcopal Church, established in 1840, is portrayed as a station for the Underground Railroad. A trapdoor at the church's entrance bears testimony that it might have served that purpose.

The cemetery on Eastville Road, a few yards from the church, suggests that Sag Harbor may have been one of the areas where African Americans survived and even succeeded. Hempstead Street is named after one African American who supposedly helped build St. David's Church. Hempstead, a respected citizen, made significant contributions to his community.

Sag Harbor, a natural port, also served as a whaling center. During the heyday of whaling, in the 18th and 19th centuries, blacks played prominent roles in the industry. Consequently, African Americans who escaped slavery preferred to serve as whalers rather than face the wrath of their previous masters.

Some of the early black leaders in Sag Harbor included Warren M. Cuffee, who was a soldier in the black regiment of the Union Army. He campaigned for Abraham Lincoln, whom he hoped would abolish slavery while in office. The Cuffees and the Pharoahs were among Native Americans and colored leaders who championed the liberation of African Americans from slavery's fetters. Bishop Thompson, who served the Sag Harbor church from c. 1841 to 1894, also advocated slavery's abolition. St. David's Church was thus a buoyant center of activity in the 19th century.

By 1927, prominent African Americans started coming to Sag Harbor for their summer vacations. During the 1930s, Maude K. Terry, a Brooklyn schoolteacher, spent her summers in rented vacation cottages in the Eastville area. Sometimes described as the founder of Azurest, she bought land in the area. In the 1940s, she convinced landlord Elsie Gale and her son Daniel Gale to subdivide property into 271 lots of 20 acres each, which were sold to friends and colleagues. In 1948, the price for the bay front lots was $1,000 and for the inland ones $750.

Maude Terry and New York City housing official and lawyer Dorothy Spaulding formed a syndicate, which helped sell the lots that fell to $450. By the 1950s, black professionals from New York City who built houses on these lots dominated the area. Early settlers in Azurest included Anna Fultz, Helen Logue Aubry, Fitzgerald Bramwell, Adele Hairston, Irma Hicks, Muriel Long, Helen V. Reid, Thomasine Smith, and Delores Williams.

St. David's African Methodist Episcopal Church in Sag Harbor, dating from 1840, is reputed to be one of the first African American churches built on the island. It was likely part of the Underground Railroad. The trapdoor at the entrance indicates that it might have been an escape route for slaves. (Author's collection.)

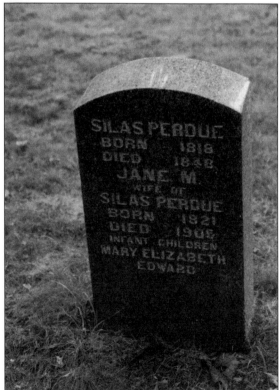

Close to St. David's Church is a cemetery that once served as a burial ground for African Americans. Pictured is the tombstone of Silas Perdue, who lived from 1818 to 1848. (Author's collection.)

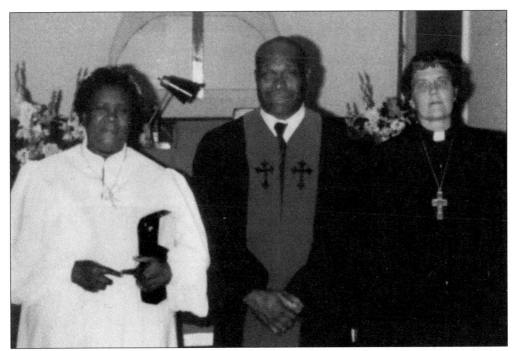

Rev. Agnes Dozier (left) has roots on Long Island dating back to the start of the century. She is a musician and founding pastor of Triune Memorial Baptist Church. Triune currently holds services in St. David's Church, but it has a site Route 114. Also shown are Rev. Fred H. Craggette and Rev. Carolyn P. Turner. (Courtesy of Kathleen Tucker.)

This is believed to be a Sears Roebuck Catalog house. Located on Route 114 in the Eastville section of Sag Harbor, it was built in 1930 by the Lipman Johnson family. In 1996, Eastville Community Historical Society acquired the property with the idea of restoring the building as its headquarters—a place for exhibitions, lectures, books, and other research materials for people studying Sag Harbor's rich history. (Courtesy of Joanne Carter.)

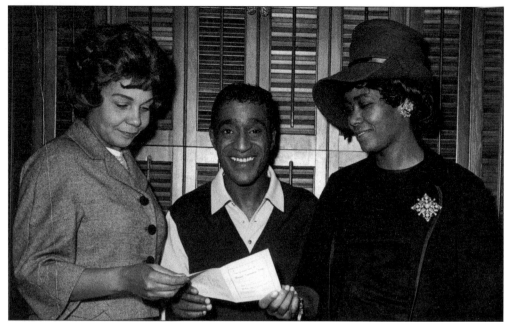

Former Sag Harbor resident Dr. Barbara Brennan (left) presents Sammy Davis Jr., star of *Golden Boys,* with the first ticket for the show, held as a community fund-raising event. She, herself, was in show business in the 1950s and the 1960s. The first African American president of the Sag Harbor Library Board, she earned a Ph.D., taught as an adjunct professor at Southampton College, and later worked at Apple Bank. She and her husband, James Brennan, first became associated with Sag Harbor in the 1940s. (Courtesy of James and Barbara Brennan.)

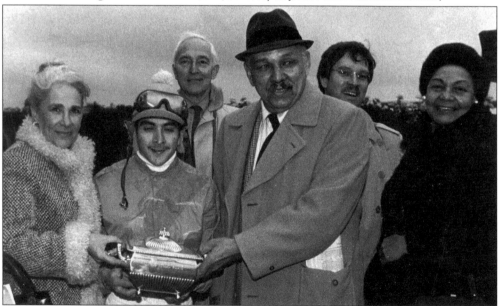

James Brennan (fourth from left), husband of Barbara Brennan (right), was one of the first elected black officials in Suffolk County. He served Sag Harbor Village for eight years as a trustee, the first African American ever to have that honor. He is shown awarding the winning trophy to the owners of racehorse Halo Dotey. (Courtesy of James and Barbara Brennan.)

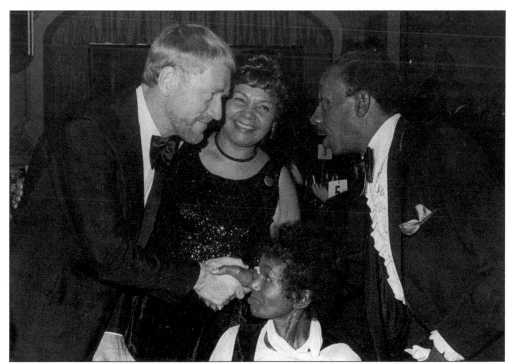

Boys Harbor was founded in the 1930s by Anthony D. Duke to assist inner-city youth. Attending a *c.* 1980 fund-raiser for Boys Harbor are, from left to right, actor Sidou, Dr. Barbara Brennan, and Dr. Dorothy Hardley Knox and her husband. (Courtesy of James and Barbara Brennan.)

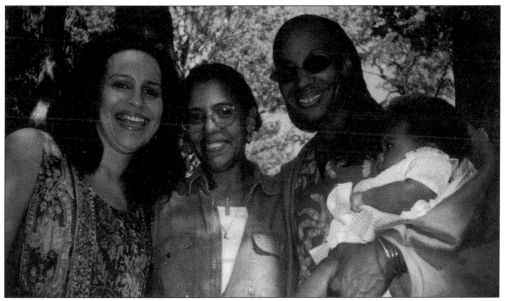

Enjoying a summer party in Sag Harbor are, from left to right, Gayle Graves, Barbara Newton, and Susan Taylor, holding her granddaughter. These women have been associated with the area since the 1950s, when some of them vacationed here. (Courtesy of James and Barbara Brennan.)

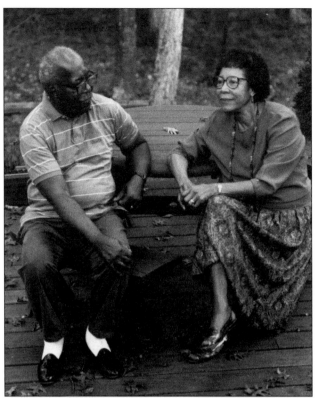

Sag Harbor resident Kathy Tucker (right) is one of the founders of Eastville Community Historical Society which, since 1981, has been researching African American history in the area. After serving as director of an early childhood center in New York City, she moved to Sag Harbor with her husband, Lemuel Tucker (left), a clinical psychologist. Since c. 1950, long before they bought their home in Sag Harbor, the Tuckers had been making visits to the island. (Courtesy of Lemuel and Kathy Tucker.)

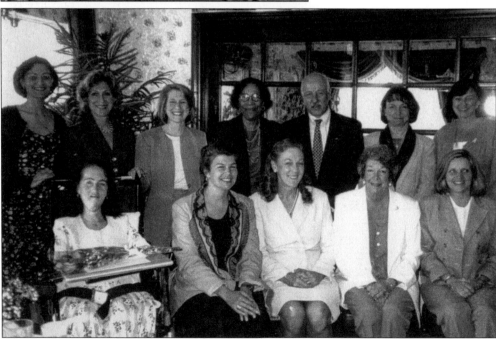

Kathy Tucker (back center) of Sag Harbor is honored with a Woman of Distinction Award. Shown standing next to state Sen. Kenneth P. LaValle, she was one of the nominees who received the award. (Courtesy of Lemuel and Kathy Tucker.)

Rae Parks and her husband were among the earliest African Americans to settle in Sag Harbor. Her husband, Dr. Marc E. Parks, was one of the first African American professors at New York University. In the early 1950s, the couple bought a house on Gull Rock Road, where she—now in her 90s—still resides. (Courtesy of Rae Parks.)

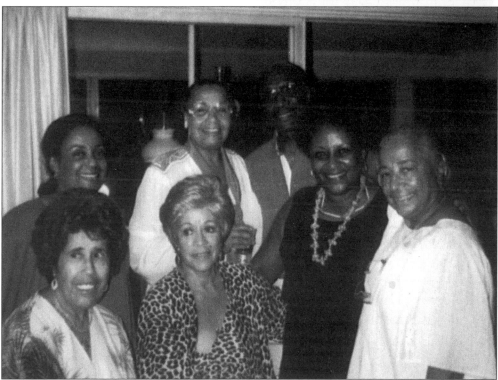

Gill Rock Road resident Rae Parks (front, second from left) entertains a group of friends at her home. (Courtesy of Rae Parks.)

When this photograph was taken in 1948, Gloria Samuels Hudnell (right) was serving as secretary to Thurgood Marshall (second from left), NAACP Legal Defense Fund counsel who later became the first African American Supreme Court justice. She trained as a secretary in New York and then worked for the NAACP from 1941 to 1949. Afterward, she was employed in the New York City school system for 27 years before retiring to Sag Harbor. Her husband's family settled in Sag Harbor in the early 20th century. This photograph dates from 1948. (Courtesy of Gloria Hudnell.)

Gloria Hudnell still lives in Sag Harbor. She is a distinguished church elder and a gardener. In this c. 1950 photograph, she holds her baby, who was born prematurely. The baby was so tiny that people wondered whether it would live. Indeed, it did, testifying to the great strides that medical technology had made by mid-century. (Courtesy of Gloria Hudnell.)

Eastville Community Historical Society of Sag Harbor was founded in 1981. The group meets monthly and focuses on community issues and historical events. It organizes seminars, lectures, tours, concerts, and special events. Several of its members have been associated with Long Island since the early 1990s. Shown are some of the founding and current members, who include Joanne Carter, president; Majorie Day, vice president; Muriel Cunningham, recording secretary; Shirley Garrett, corresponding secretary; and Mercedes Cook, treasurer. (Author's collection.)

Retired state Judge Larry Pierce swears in the Eastville Community Historical Society executive board. Pierce bought a house in Sag Harbor after other African American professionals moved into the area in significant numbers from the 1940s onward. (Author's collection.)

Dr. David Carney served in the United Nations for more than 30 years. Originally from Sierra-Leone, he bought his house in Sag Harbor in the 1960s. A diplomat, professor, scholar, and author, he has written a number of books, taught African literature at Southampton College, and played a prominent role in Eastville Community Historical Society. (Author's collection.)

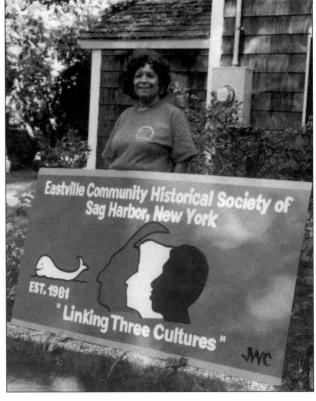

Over the years, Eastville Community Historical Society member Shirley Garrett has donated her time to many worthwhile community activities. In this photograph she is standing in front of St. David's African Methodist Episcopal Church, one of the oldest African American churches on Long Island. Built in 1840, the church has a trapdoor that indicates a connection with Underground Railroad activities during the slave era. (Author's collection.)

The founders of East End Artists' Association gather for a photograph. They are, from left to right, Michael Butler, Mary E.B. Diamond, Robert Diamond, Morgan Monceaux, Rosalind Letcher, and Martin Butler. In the early 1990s, the association was called the Onyx Group and it was one of the first black artist organizations established in eastern Long Island. The Butler twins were born and raised on Long Island. (Courtesy of Mary E.B. Diamond.)

Mary Diamond, one of the leading African American artists on the East End of Long Island, stands before her work. A painter of both portraits and landscapes, she has the ability to blend colors in their natural form and to capture her subject in almost photographic detail. (Courtesy of Mary E.B. Diamond.)

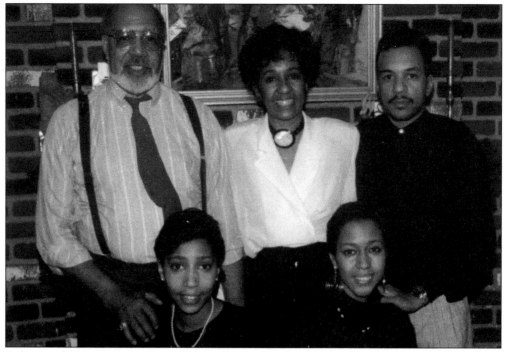

Robert and Joanne Carter have been associated with the island since the 1940s. They are shown with their children, from left to right, Tiffany, Janine, and Tony. Hardworking members of the Eastville Community Historical Society, the church, and the community, the Carters bought property in Sag Harbor in the early 1950s, when they were working in New York City, and moved in after they retired. (Courtesy of Robert and Joanne Carter.)

Whaling was a big industry on the East End in general and in Sag Harbor in particular during earlier centuries. This painting by artist Joanne Carter captures the spirit of that industry.

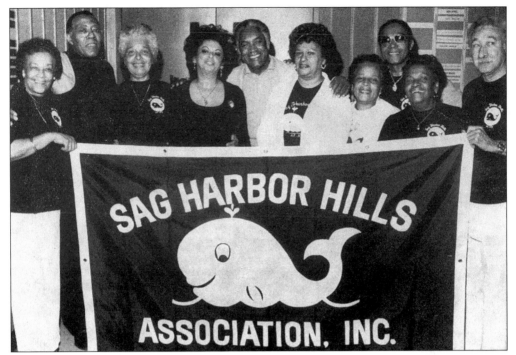

Members of Sag Harbor Hills Improvement Association discuss issues relevant to their neighborhood. The group also organizes parties, special events, and anniversaries.

Sag Harbor Hills Improvement Association holds a footrace as one of its special events.

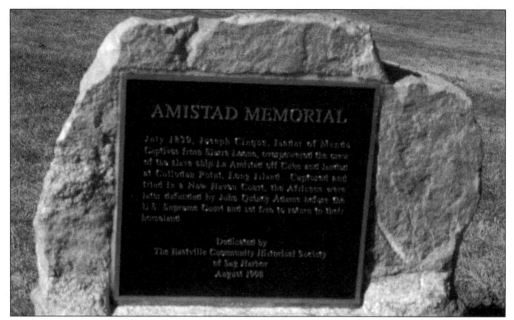

At Montauk Lighthouse, members of Eastville Community Historical Association dedicate a monument in memory of Joseph Cinque and fellow Africans who came ashore close to Montauk Point following the 1839 Amistad Revolt. (Courtesy of Joanne Carter.)

At the dedication of the Joseph Cinque monument are, from left to right, Dick White, Montauk Lighthouse Historical Society; Pierce Hance, the mayor of Sag Harbor; Joanne Carter, president of Eastville Community Historical Society; and Marjorie Day, vice president of the society. The ceremony took place in August 1998.

Majorie Hays graduated from New York City schools and worked with the Red Cross and Bellevue Hospital. In the 1940s, she started coming to Sag Harbor. She currently resides in the historic Eastville area of Sag Harbor. This 1943 photograph shows her with her son, Rudy—a sergeant with the New York City police who retired to Sag Harbor in 1984—and her daughter, Peggy—a reweaver who is now retired and living in California. (Courtesy of Majorie Hays.)

This is the Majorie Hays home at 4 Cuffee Drive in Sag Harbor. Built in the 1940s, the house is still solid and attractive. It has three bedrooms, a living room, a dining hall, a kitchen, and a basement. (Courtesy of Majorie Hays.)

Martha Phillips, widow of business executive J. Foster Phillips of Queens, enjoys her Sag Harbor home. A resident since the 1950s, she previously worked with the New York Board of Education. She is a respected member of the African American community. (Courtesy of Majorie Hays.)

Bishop Herbert Thompson of Ohio stands with a neighbor in front of his summer home in the Eastville section of Sag Harbor. The house was built in the early 1900s. (Courtesy of Majorie Hays.)

Frank W. Wimberley is one of the foremost African American artists on the island. His works are on display in galleries throughout the island and elsewhere in the world. He owns a home in Sag Harbor. (Courtesy of Frank W. Wimberley.)

Artist Frank W. Wimberley's *Trestle Portrait* is a 25-by-23-inch paper collage done in acrylics. (Courtesy of Frank Wimberley.)

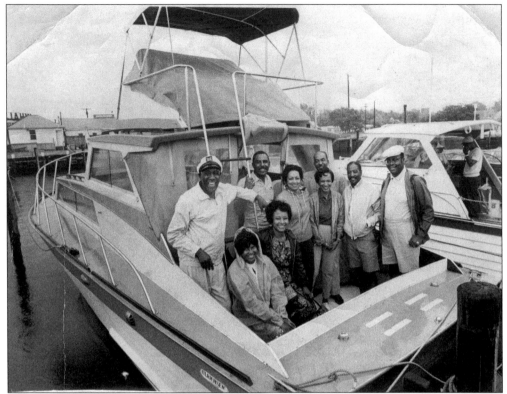

Aboard the *Lady Gwen* are seagoing members of the black fleet. This photograph was taken *c*. 1950. (Courtesy of James and Barbara Brennan.)

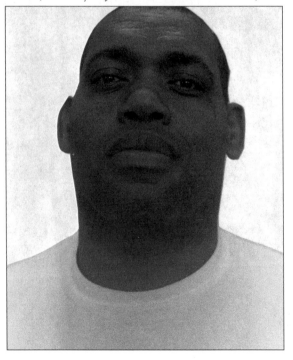

Lester Ware, a trainer and one of the few African Americans with his own business in Sag Harbor, is the son of Lucius Ware, the leader of the NAACP on the East End of Long Island.

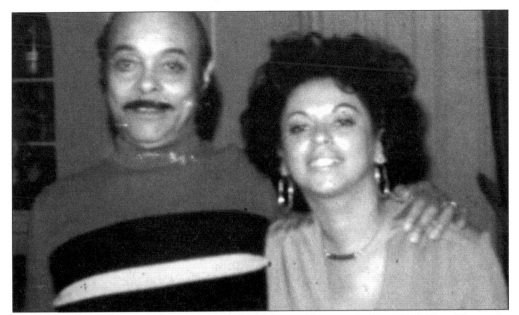

John B. King was one of the leading African American educators in New York City. He rose in the system and served as a principal and an associate superintendent. He came to Sag Harbor in the 1940s and bought an exquisite parcel of beachfront property. Shown with him is his daughter Lynne King Eberhardt. She and her husband, Russell Eberhardt, started coming to Sag Harbor for summer vacations in the 1950s and now reside in the area.

Nancy Stevens became the first African American to teach in the Sag Harbor School district. Her parents moved to the East End in the early 1900s, and she was born and raised in Southampton. Active in the church and community, she holds both a bachelor's and a master's degree. (Author's collection.)

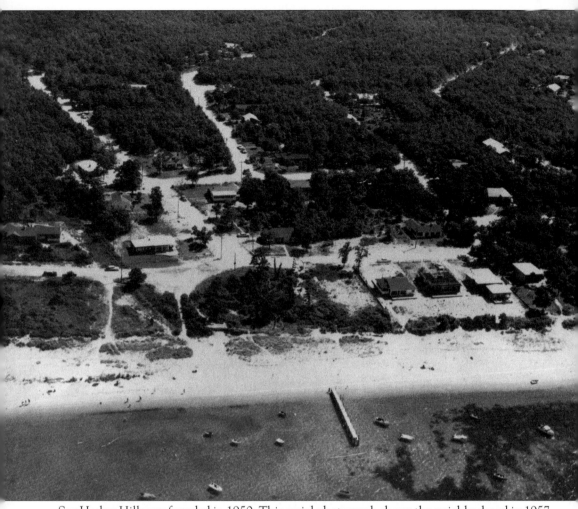

Sag Harbor Hills was founded in 1950. This aerial photograph shows the neighborhood in 1957. In the view, from left to right, are Hillside Drive East, Hillside Drive West, Harbor Avenue, and Beach Avenue. Some 20 summer homes, dirt roads, and a boat pier extending from the beachfront property of W. Pickens are visible. (Courtesy of James and Barbara Brennan.)

Six

SOUTHAMPTON
CHALLENGE AND CHARM

Founded in 1641, Southampton has an impressive history. With its beauty, beaches, and affluent population, the city has long attracted tourists from all parts of the world. African Americans, along with some of the other residents, struggle against the backdrop of magnificent homes, splendid landscapes, and rolling coastline. A number of them have excelled. They live in a concentrated area on Hillcrest Terrace and in areas throughout the city, such as Halsey Avenue. Today, the city has African American teachers, police officers, nurses, doctors, lawyers, and professors.

Originally Native American territory, Southampton fell under British authority in 1641, which ushered in a new era in the area's history. As is true elsewhere on the island, the date when the first African Americans arrived in the area remains a subject for historical research.

Opinions vary. Some people claim that a few African Americans were residents of the area prior to the slave era. Others assert that their presence on the island cannot be dissociated from slavery. Whatever the case, by the late 1800s, after the Emancipation Proclamation, some African Americans in the South left what they perceived as the harsh and inhuman conditions for opportunities in the North.

By the 1850s, a few must have been residents in the city. After the Civil War ended in 1865, many African Americans migrated from the South to the North. At the beginning of the 20th century, many came as seasonal workers in search of higher economic status. Over the years, they served as landscapers, construction workers, beauticians, businessmen, ministers, deacons, and farmhands. Today, a number of African Americans in Southampton still have families and maintain contacts in the South.

In the 1920s, expectations of work and higher wages attracted African Americans from the South, specifically from Virginia and the Carolinas to work in East End potato farms and perform domestic chores. The earliest ones settled along Bridgehampton and Halsey Avenues in Southampton.

African Americans started building homes on Hillcrest Avenue in the 1920s and the 1930s. Eventually, the area expanded to include Hillcrest Terrace, Miller Road, and Windward Way. It was called "the Hill." One of the early migrants, farmer and landscaper Percy Kingsbury, bought land and built houses, which he later sold. He was known as "King." In the 1920s, he and his brother migrated from the South, following his brother-in-law. He worked as a domestic servant, a farm worker, a landscaper, and a handyman. A highly respected man, he bought 100 undeveloped lots on the Hill, which he farmed and later sold to others.

Another early settler was Deacon Ray Saunders, who migrated from North Carolina in 1928. He met his wife, Thelma Saunders, in Southampton. She had also come to pick potatoes. In the 1940s, they bought a house on the Hill. They raised nine children, including Ray Saunders Jr. and Sharon Saunders.

As people migrated from the South, the need for a spiritual center became a reality. In 1932, early migrants started the first African American church: First Baptist Church at 57 Halsey Avenue. Chartered members included Rev. W.M. Parham and Abbie Griggs. Other early church leaders were Jacob Gooden, Joseph Johnson, Abner Dozier, George Turner, and Waverly Wingfield. Associated with the church were the Johnson, Jefferson, Saunders, Seymore, Ward, Baxter, Spellman, Martin, and Hayes families. The Seymores were one of the largest African American families to settle in Southampton. Rev. John V. Williams led the church into the new millennium.

In the 1930s, after more African Americans had come to Southampton, the need for a new place of worship led to the birth of Community Baptist Church. Some members of First Baptist Church teamed up with the newcomers to launch the new church. Community Baptist members included George Turner, Georgia Bight, Eva Dossier, and Mary Grills.

The Hurricane of 1938 destroyed Community Baptist, and a new church was built the same year. Rev. Moses Dickerson served as the first pastor for almost two decades, starting in 1939. After he resigned, Rev. Walter Willoughby pastored the church from 1956 to 1961. Rev. John Mason replaced Willoughby and served from 1962 to 1967. Despite the fact that he increased the membership and instituted tithing, he left the church amidst controversy and litigation. Rev. Raymond Lee then became the new pastor in 1968. He embarked upon a reformist path and injected new spirit into the church. With the collaboration of trustees and deacons—Zenus Hartfield, Emmanuel Ward Jr., E.R. Spellman, and Samuel Barner—the church, though small, waxed strong into the 21st century.

In the 1990s, few African Americans served in local school, business, or government positions. A controversy erupted in 1999–2000 over the hiring of town attorneys. Five positions opened and no minority person was hired during the initial phase. Lucius Ware, president of the regional NAACP, and members of that association, mounted a 1960s-type protest. As a result, Wanda Brown, a qualified African American attorney with a family history in the area, emerged as the first African American town attorney. Rena Brown, a theology graduate, became the first African American court clerk of Southampton Justice Court. The African American presence in Southampton is noticeable and may, depending upon the circumstance, rise or fall.

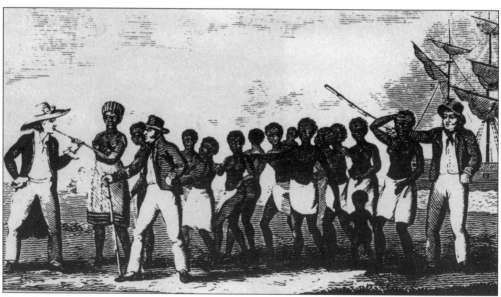

This drawing of masters and their slaves captures the philosophy that guided slavery. Some historians believe that natural ports such as Greenport, Sag Harbor, and James Port may have served as entry points for slaves in the 17th and 18th centuries. (Courtesy of Southampton Historical Museum.)

Historical records indicate that there were slaves on Long Island during the 17th and 18th centuries. These illustrations depict the practice of slavery. (Courtesy of Southampton Historical Museum.)

Pyrrhus Concer was born on March 17, 1814, in Southampton to a slave mother. He lived a hard, remarkable, and adventurous life. He worked for the Pelletreau farm and was freed at age 21. He became a crewman aboard Capt. Mercator Cooper's ship *Manhattan*, which rescued shipwrecked Japanese sailors and transported them home in 1845. When he arrived in Japan, his unique color and demeanor made him an instant hero and object of curiosity. During the 1849 California gold rush, he was prospector. Later, he married and had a small boat that he sailed across Lake Agawam. He earned respect as a pleasant man who took passengers from one part of Lake Agawam to the beach for a modest fare of 5¢. He died at age 84. (Courtesy of Lucius Ware.)

This memorial was erected on the northwest shore of Lake Agawam in honor of Pyrrhus Concer. Born a slave on March 17, 1814, Concer died on August 23, 1897. The epitaph set in a granite headstone pays lasting tribute to this historical figure on Long Island. It reads: "Though born a slave, he possessed virtues without which kings are but slaves." (Author's collection.)

Percy Kingsbury was not only one of the pioneer African American settlers on what is now described as the Hill but also one of the first business entrepreneurs in the area. Like most African Americans, he came from the South and worked on farms in the early 1900s. He bought large tracts of land on Hillcrest Terrace, where he built houses and later sold lots to interested parties. He emerged as one of the first African American landowners and businessmen in Southampton. (Courtesy of Samuel Johnson.)

The Seymores are one of the oldest and largest African American families in Southampton. Shown, are Mary Margaret Barrington and George Seymore. (Courtesy of Mary Trafton.)

Pictured in front of her home is Mary Trafton, one of the first African American teachers from Southampton. In 1956, after earning a degree in elementary education from Elizabeth City University in North Carolina, she came to Southampton to look for a job. At that time, however, African American teachers were not part of the school system. To survive, she worked in a factory, did domestic labor, and picked potatoes on farms. In 1962, she became a caseworker with the Riverhead and Bayshore Welfare Department. Finally, in 1966, she got a teaching job with Middle Island Central School District. She received a master's degree in liberal arts-education from State University of New York, Stony Brook in 1976. She retired in 1995, having taught first, second, and third grades for 29 years. Currently, she serves as the secretary of First Baptist Church of Southampton. (Courtesy of Mary Trafton.)

Longtime Southampton resident Madeline Dozier was active in community development. She was also a mentor, church deaconess, singer, and missionary member. (Courtesy of Rev. John V. Williams and First Baptist Church of Southampton.)

This is the 1932 building of First Baptist Church of Southampton, which was destroyed in 1936. Located at 57 Halsey Avenue, the church was reconstructed in 1942 under the leadership of Rev. W.H. Green. More than 12 pastors have served the church, including the current one, Rev. John V. Williams. (Courtesy of Rev. John V. Williams and First Baptist Church of Southampton.)

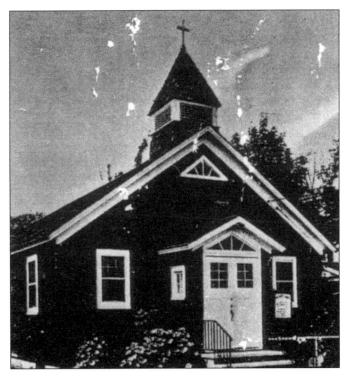

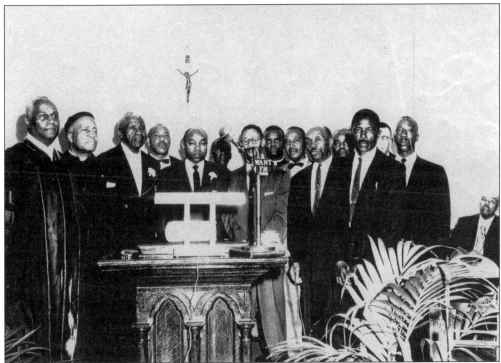

Kings Chapel was established in 1938 in the Jefferson family home. This photograph shows East End clerics at the 1959 dedication of the church building at 59 Hillcrest Avenue in Southampton. (Courtesy of Mrs. Spellman.)

Pianist and musician Arthur Davis (right) has played with leading artists on the East End. He is a member of Davis family, which has a long history in the area. With him is Lucius Ware, one of the first African American teachers and school administrators in Eastern Long Island and the president of the regional NAACP. (Author's collection.)

Southampton artist and sculptor Perry Ward (center) belongs to one of the oldest African American families in Southampton. With him are his wife (left) and East Hampton resident Audrey Gaines (right). Audrey Gaines, who holds a master's degree in social work, serves with the Senior Citizen Recreation Center in East Hampton and is a leader in church and community activities. (Author's collection.)

Kathleen Davis served with the Head Start program for almost three decades before founding the Southampton day-care center Fountain of Youth. The center, which opened in 1988, moved to a new building on Davis Lane in 2000. Born in Camden, North Carolina, in 1941, she graduated from Marion Anderson High School in 1959 and relocated to Southampton. She is an active member of Community Baptist Church in Southampton. (Courtesy of Kathleen Davis.)

The Southampton group Mighty Gospel Keys entertained with gospel music for a number of years, from the 1970s to the late 1980s. The group toured the island and performed in New York City, Connecticut, Pennsylvania, and New Jersey. Members, from left to right, are Chester Cherry, lead singer and guitarist; Roy Banks, lead and tenor singer; Manford Gregory, lead and baritone singer; Noah T. Simmons, manager; Walter Green, lead and baritone; Oscar Gaynor, bass; and Walter Barnard, bass. (Courtesy of Noah Simmons.)

Charles Thomas Cannon (center), known as "King Charles," plays the tenor saxophone. He was one of Long Island's foremost musicians and bandleaders between the 1940s and the 1990s. Born in Wilson, North Carolina, in 1930, he lived on Miller Road in Southampton and was married to Gloria E. Cannon, with one daughter, Bonnie M. Cannon, and a grandson, Spencer Kyle Cannon. Although he was a tenor saxophonist, he played all instruments, including the drums. He accompanied such giants as Dexter Gordon, Stan Getz, Duke Si, Sonny Stitt, John Coltrane, and "Prez" Lester Young. He was an assistant bandleader when people started calling him King Charles. His band played at the Burkes Road House, which was a traditional restaurant, bar, and entertainment spot on North Sea Road. The band played a mixture of rhythm and blues, pop, soul, salsa, and rock and roll. Band members included drummer Butch Walker, keyboardist Dave Ostertag, bass Steve Shaughnessy of Southampton, and two harmonica players—Don Saginario of Hampton Bays and Ed Cuccia. (Courtesy of Gloria E. Cannon.)

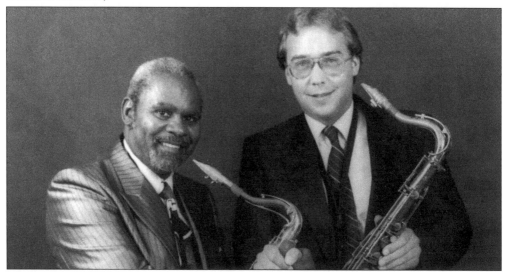

Charles Thomas Cannon (left) poses for a photograph with a friend and colleague from Southampton. A veteran musician who left the army in 1946, "King Charles" led a five-piece band and had a unique style of communicating with his audiences. Like sax showmen King Curtis and Junior Waler, he moved from table to table playing solos. He also played backup for stars, notably Little Richard, the Shirelles, Jackie Wilson, and Big Joe Turner. (Courtesy of Gloria E. Cannon.)

Noah T. Simmons came to Southampton with his wife in 1938. A hardworking and responsible man, he started out on the farms and later opened his own landscaping company. He built his home on Halsey Avenue, where he and his wife raised their children. This photograph dates from 1940. (Courtesy of Noah T. Simmons.)

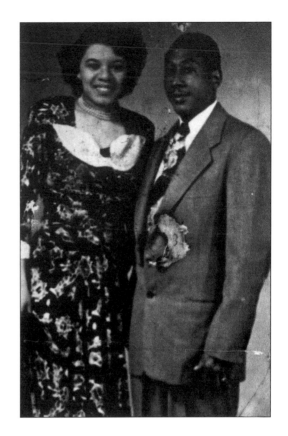

Pictured are the Simmons sisters: Brenda, Sandra, and Mary Jane. The photograph was taken in Southampton in the late 1950s. (Courtesy of Brenda Simmons.)

William Henry Martin was born in 1858 in Richmond, Virginia, and his wife, Ida Bailey Martin, was born in Southampton Hospital in 1885. They lived on Bailey Street, which was named for her family, one of the oldest black families in Southampton. Her parents escaped the hardships of the South in the 1800s and migrated to Southampton. (Courtesy of Harry Martin.)

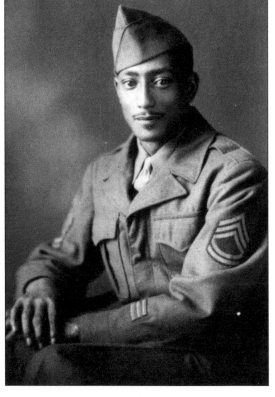

Harry Martin, son of William Henry Martin and Ida Bailey Martin, was born in 1918 in Southampton. He served with the U.S. Army during World II in Australia, Japan, and New Guinea. After returning to Southampton in 1946, he served the community and his church, First Baptist Church of Southampton. (Courtesy of Harry Martin.)

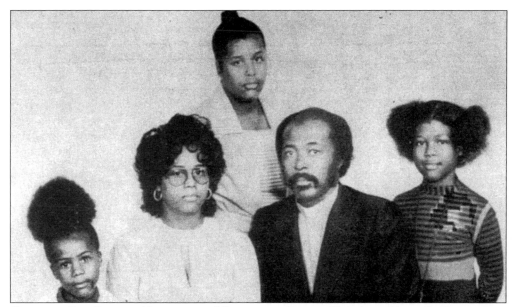

Shown are Rev. Raymond Lee, pastor of Community Baptist Church, and his wife, Yvonne Lee, and their children. Lee, who came to the church in 1968 after a controversy had erupted, was able to restore the morale. He built a new church and led it for more than 30 years. Founded in 1937, the first church building was destroyed by the Hurricane of 1938. The first pastor was Rev. Moses Dickerson (1939–1956), followed by Rev. Walter Willoughby (1956–1962) and Rev. John Mason (1962–1967). (Courtesy of Rev. Raymond Lee and Community Baptist Church.)

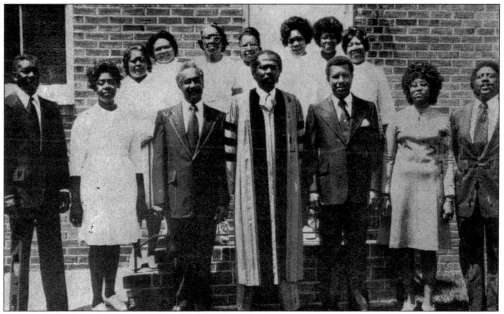

The Community Baptist Deacon and Deaconess Board served for more than 30 years. Among the members pictured are Rev. Raymond Lee (center) and Deacon Zenus Hartfield (on the pastor's right), who led the board for almost 40 years. (Courtesy of Rev. Raymond Lee and Community Baptist Church.)

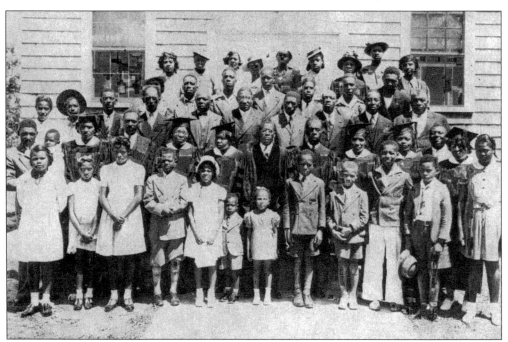

The Hurricane of 1938 devastated Southampton and the East End. It shattered houses and resulted in the deaths of many people. One of the churches it destroyed was Community Baptist Church. The photographs show the cornerstone of the new church and some of the founding members of Community Baptist. (Courtesy of Pastor Lee and Community Baptist Church.)

EPH. 2:20
COMMUNITY BAPTIST CHURCH
ORGANIZED 4·22·1938
CORNERSTONE LAID 9·26·1948

Lucius Ware (third from left) became one of the first schoolteachers, administrators, and principals who served on Long Island. After graduation from Wilberforce University, he taught in several school districts in Ohio and Long Island in the 1950s and 1960s. Currently the president of the Eastern Long Island Chapter of the NAACP, he has campaigned for the recruitment of minority teachers and educators and led a protest that resulted in the appointment of the first African American attorney in the village of Southampton. Shown with him are two East End artists (left) and author Jerry Komia Domatob. (Author's collection.)

Mathew Gregory (center) was one of the early grand masters of Aurora Chapter No. 66 and Sons of Gideon Lodge No. 47 of Southampton. He came from North Carolina and worked as a field hand, a butler, and a chef. He was one of those instrumental in purchasing the former Bethel Church, now called the Sons of Gideon Lodge. The group formerly met in the old Bethel Presbyterian Church. Also pictured, from left to right, are Mary Elizabeth Gregory, Katie Gregory, Mathew Gregory, Carrie Hudgin, and Madelene Dozier. (Courtesy of Gloria E. Cannon.)

Andy Malone (front row, second from left) played on the Southampton High School basketball team in the 1940s as number 5. Born on the East End in 1926, he attended Pierson High for 11 years and graduated from Southampton High in 1944. He served in the U.S. Navy from 1945 to 1946. Over the years, he has lived in East Hampton, Sag Harbor, and Southampton, where he has been active as a businessman and has served as an elected Democratic party official at the state, county and town levels. (Courtesy of Andy Malone.)

Clarence "Foots" Walker (left) was one of the most famous members of Long Island's school basketball teams of the 20th century. Between 1967 and 1970, the Southampton Mariners won 61 consecutive games, a record that few schools in Nassau or Suffolk have achieved. Pictured with Walker is Courtney Pritchard, whose skill led the Southampton team to similar victories in the late 1990s. After Southampton High, Walker attended Vincennes Junior College, which he led to its 1972 national championship, and then went on to West Georgia College, which he helped advance to the 1974 National Association of Intercollegiate Athletics tournament title. On both occasions, Walker was recognized as Most Valuable Player. He was drafted into the National Basketball Association, where he played for 10 years, from 1974 to 1984, setting Cleveland's career record for steals. In 1998, *Newsday* included him among its Elite 33—a listing of the best high school athletes from Long Island. (Courtesy of Mike Mackey.)

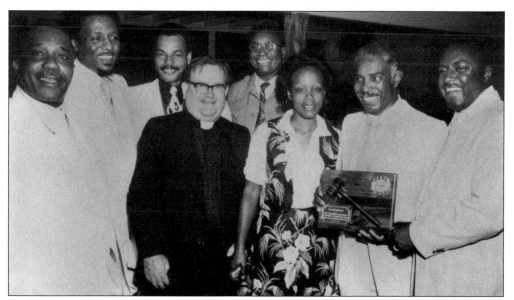

Andy Malone (second from right) is honored for meritorious service to the community. With him are his wife and other community leaders, including Rev. Marvin Dozier (right), pastor of Unity Baptist Church. (Courtesy of Andy Malone.)

Rena Brown (center) became the first African American to serve as senior clerk of Southampton Justice Court. After graduation from Freeport High School in Illinois, she attended Northwestern University, from which she earned an associate degree in business administration. She later received a bachelor's degree in religious education from the O.M.K. Religious Training Institute in Freeport. Secretary of Galilee Church of God in Christ, she helps with the usher board and the radio ministry. Pictured with her are Judges Barbara Wilson and Edward Burke. (Author's collection.)

Wanda Brown became the first African American to serve as a village attorney in Southampton, based on experience she had gained as a trial lawyer. A 1972 graduate of Riverhead High School, she was also the first African American Rotary exchange student to go to Sweden. She earned a bachelor's degree in religion and sociology from Syracuse University in 1976 and a law degree from Cornell University. Her parents, William and Mary Totten, were laborers who migrated from Powhatan, Virginia, to New York as seasonal workers. Active in King's Chapel Church of God in Christ, she is married to Donald Brown, a retired New York City transit worker, and they have a son, Matthew Brown. (Author's collection.)

Caprice and Annette Crippen are the first African American mother and daughter duo to graduate from Long Island University's Southampton College. Annette Crippen (second from right) earned a master's degree. She is the director of Southampton College's Center for Multicultural Programs. Caprice Crippen (third from right) earned a bachelor's degree in communications. Also pictured at an art show held at the college are, from left to right, Brenda Simmons, a former counselor with the center who heads the Suffolk County Economic Opportunity Office in Riverhead; graphic design major Noel Diaz, captain of the college basketball team; faculty member Dr. Jerry Komia Domatob; and communications graduate Trisha Alameda (far right). (Author's collection.)

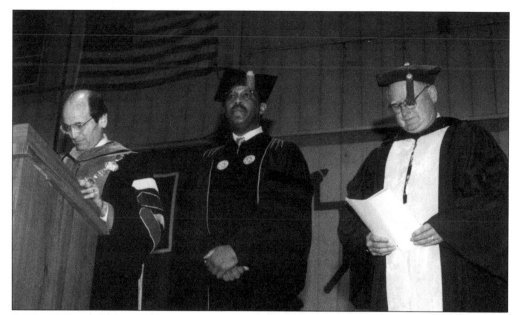

Dr. Juni Wingfield (center) receives an honorary doctorate from Long Island University for his contributions as community liaison with Southampton High School and as a member of the Southampton Board of Education. He is flanked by Long Island University Pres. David Steinberg (right) and Dr. Chuck Hitchcock, division director for the social sciences. Wingfield, who belongs to one of the oldest African American families in Southampton, graduated from Southampton High School and Southampton College. (Courtesy of Southampton College Public Relations Office.)

Shinnecock elders congratulate one of their sons, Jay Bryant (second from right), on his graduation from Southampton College. Bryant, who earned his degree in communications, played basketball at the college. The photograph was taken at his graduation party. (Author's collection.)

Sherry Blakey-Smith, the Shinnecock education coordinator for Southampton High School, has written grants to promote various aspects of Shinnecock and Indian education and has served as a counselor and mentor. She has earned high respect for strongly encouraging students to pursue their courses with determination and discipline. (Courtesy of Sherry Blakey-Smith.)

Long Island University awards honorary doctorates to William Kennard (left), the first African American chairman of the Federal Communications Commission (FCC), and Dr. Frances Berry (right), chair of the U.S. Commission on Civil Rights. An author, professor, lawyer, and scholar, she earned her B.A. and M.A. degrees from Howard University and her Ph.D. and J.D. from the University of Michigan. She served as assistant secretary for education in the U.S. Department of Health, Education and Welfare and cofounded the Free South Africa Movement, launched in 1984. Kennard earned his B.A. from Stanford University in 1978 and served as chief legal adviser to the FCC before becoming chairman in 1997. (Courtesy of Southampton College Public Relations Office.)

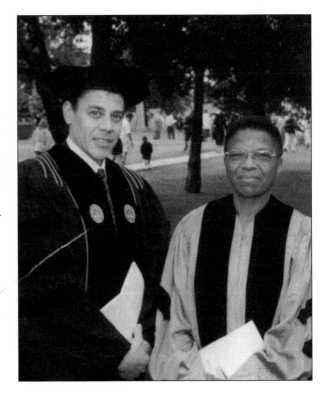

Members of First Baptist Church of Southampton pose for a "family" photograph. All of them had relatives who came to Long Island in the first half of the 20th century.

Larry Toler (right) served as a technician with Brookhaven National Laboratory for several years. A former military officer, he served in Japan and married to his wife, Tomoko, while on duty. A Mason, community leader, and politician, he is one of the few African American Republicans on the East End. (Courtesy of Larry Toler.)

Raymond and Thelma Saunders pose for a photograph in their Southampton home. He was born in 1913 and she in 1916. They married in 1933 and had nine children. In the early 1930s, they migrated from North Carolina to Southampton and were among the first settlers in the African American neighborhood on Hillcrest Avenue. They worked for Warren and Grace Brandt. Saunders was a charter member of First Baptist Church of Southampton, where he served as deacon for more than four decades. (Courtesy of Hazel Sharon Saunders.)

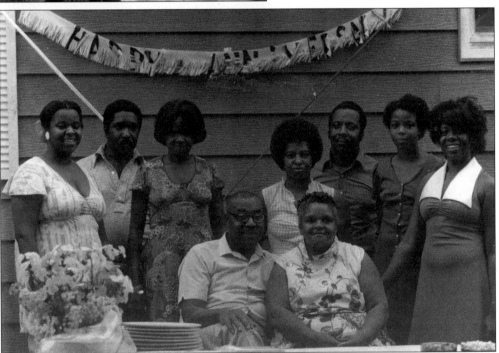

This is the Saunders family of Southampton at the anniversary wedding celebration of their parents Raymond and Lee in the 1960s. From left to right are Janet Saunders; Valerie Hudgins and her former husband, Carlos Williams; Erma Saunders and her husband, Shirley Saunders; Catherine Saunders; and Thelma Saunders-DeBoard. (Courtesy of Hazel Sharon Saunders.)

Hazel Sharon Saunders (center) of 72 Hillcrest Avenue, Southampton, receives the New York State Woman of Distinction Award for founding the Hillcrest Avenue Neighborhood Kids Union, ThankY, and for working in her community. Born in 1946 in Southampton, she graduated from Southampton High in 1964 and attended Norwalk Community College and the University of Bridgeport. She operated a day-care center in Connecticut for over three decades and returned home in 1997 to help take care of her aging mother. With her are state Sen. Kenneth P. LaValle and her daughter Catherine Saunders of Stamford, Connecticut, who was born in Port Jefferson and who, today, is a social worker in Connecticut. (Courtesy of Hazel Sharon Saunders.)

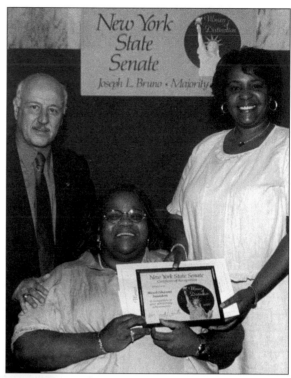

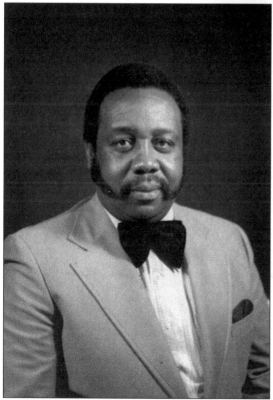

Elder Raymond Saunders III attended Southampton schools and later earned a general equivalency diploma (GED). He graduated from Oakwood College in Alabama and received a doctorate in theology. He is currently an evangelist for the Eastern Conference of the Seventh-day Adventists.

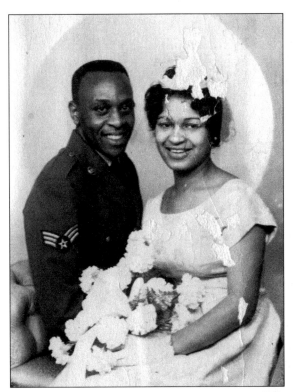

Omie Saunders graduated from Southampton High School and served in the air force for nearly two decades. His wife, Doris Saunders, is a member of the Hopson family of Bridgehampton and is a state-registered nurse. The couple now live in Maryland. (Courtesy of Hazel Sharon Saunders.)

Shirley Saunders is pastor of Feed My Sheep Ministries in Middle Island. After graduation from Southampton High School, he worked, raised a family, and was called to the ministry in 1979. (Courtesy of Hazel Sharon Saunders.)

Rev. John V. Williams Jr. became pastor of First Baptist Church of Southampton in 1988, after attending Bible schools. His wife, Joyce Williams, was a New York schoolteacher. Their son is son Rev. Dwayne V. Williams.

Dr. Florence Rolston became one of the first African Americans to practice obstetrics and gynecology on the East End. She earned a B.S. in chemical engineering from Massachusetts Institute of Technology and an M.D. from Morehouse School of Medicine in Atlanta. She earned her graduate medical certificate from the University Medical Center, Stony Brook, where she did her residency. A fellow of the American College of Obstetricians and Gynecologists, she is on the medical staff at Southampton Hospital and serves as a physician in six practices. (Courtesy of Dr. Florence Rolston.)

Hortense Gordon was one of the first African American teachers recruited in the Southampton School District. She served the district for over three decades and won respect and admiration from students and parents. The daughter of late Rev. Ralph Spinner, she was educated in the local school system. She earned her undergraduate degree at Howard University in Washington, D.C., and did graduate work at Hampton College. (Courtesy of Southampton College Public Relations Office.)

Delano Stewart is the founder and publisher of the Long Island newspaper *Point of View*. A Columbia University graduate, he has served as an insurance manager, Long Island manager for Jesse Jackson's presidential campaign, and a community developer.